HERSH COHEN

STEEL & ROSES

American Prints in the Hersh Cohen Collection &
Botanical Books in the Fern Cohen Collection

Part 1
AMERICAN
PRINTS

THE
GROLIER CLUB
New York
2011

Catalogue of an exhibition held at
The Grolier Club
September 8 through November 4, 2011

ISBN: 978-1-60583-036-0

Contents

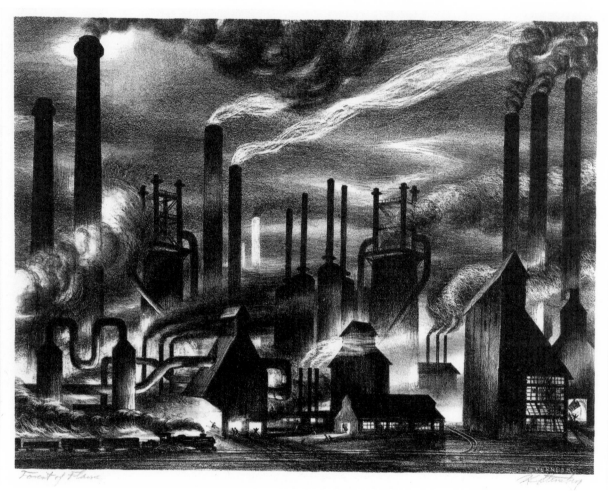

Forest of Flame

CAT. 1

Foreword

*I*N 1997, I WROTE AN ESSAY about my collecting for an exhibition of a selection of a hundred of my Depression-era prints at the Heckscher Museum in Huntington, New York. Fourteen years later, the collection has grown, holes have been filled, the original "wish list" has been nearly marked off, and, of course, as any collector would understand, new wishes have been added to the list. Thirty-five years of going to exhibitions, visiting dozens of museums and libraries with American collections, poring through dealers' catalogs and bins, and enjoying the company of dealers, curators, and fellow collectors have brought me to the point where I have as near a sense of completion as possible. I have the daily enjoyment of living with the prints and the pleasure of having put the collection together.

Probably the most interesting thing about collecting that has occurred in our lives since my last essay is my wife Fern's discovery of early botanical books. After over two decades of enjoying and tolerating my obsession, but not actually participating, she was figuratively thunderstruck by the beauty of these books about fruits and flowers. It has been great fun watching her go through the same steps of collecting that I have experienced. A Master Gardener, she found her collecting niche in the books.

My parents came of age during the Depression, and except for a painting by an artist who was a childhood friend of my dad's, art was too much of a luxury to even think about. The Cleveland Museum, which our elementary school class would visit every year, held more attraction for me because of the armor collection than for its splendid American paintings, which we now cannot wait to see on each visit back to where I was raised.

In the early years of our marriage, the closest I came to art was a poster of George Bellows's painting of the Dempsey-Firpo fight, which we placed above our son's crib. I had no idea who Bellows was at the time, but the poster was a pretty good action picture and seemed cool for a boy's room. My inattention to art lasted until 1976, the year of the Bicentennial. On a quest for a roll-top desk, I wandered into a small gallery and noticed a few nice-looking landscape paintings by American artists of the nineteenth century. I impulsively bought a very inexpensive one, and went to our local library to start reading about American art. Luckily, because of the year, many museums were having special exhibitions of American paintings, and, in some cases, prints. I was smitten with the glorious landscape paintings by artists of the second half of the nineteenth century and with those my collecting habit was born.

A few things happened that brought prints into focus. My father-in-law had a friend who owned a small framing shop in Union Square. He learned of my new interest and invited

me to see some prints he had acquired in the 1930s from artists in exchange for framing and wanted to sell. The first print I saw and bought was *Forest of Flame* by Harry Sternberg (cat. 1). It is a glorious lithograph of steel mills with billowing smoke and flames. When I was a boy, my father used to take me down to the Flats in Cleveland to watch steel being poured at night. It was like seeing fireworks. The print, evocative of pleasant childhood experiences, was perfect. It was very affordable and remains one of my favorite images.

A bit later, Fern and I went to the Metropolitan Museum exhibition of Childe Hassam's flag paintings. In an adjacent room were exhibited a group of prints by contemporaries of Hassam, including Joseph Pennell's urban landscapes. I set out to look for Pennell's prints. Ads in the paper sent me browsing through the inventory at Associated American Artists, a gallery devoted to American prints. There I discovered a group of artists about whom I knew nothing but whose works triggered an immediate reaction akin to when I saw *Forest of Flame*. I purchased Howard Cook's *Times Square Sector* (cat. 2), and the gallery personnel assured me that he was an artist worth collecting. Little did I realize then how many Cooks I would eventually covet and acquire. Armin Landeck (cat. 24 and 27) was another master printmaker whose work was quite accessible and provided enormous pleasure.

A theme was emerging. The Smithsonian had published a pamphlet entitled *The Image of Urban Optimism* (1977) for a traveling exhibition. It became a prescription of sorts for me. I started to think of urban landscapes as the twentieth century equivalent of those nineteenth-century landscape paintings I loved so much. The images of the rise of the city and its buildings echoed for me the reverence painters of the previous century had for the untouched wilderness.

Also in the boxes at Associated American Artists was a print by James Allen titled *Teeming Ingots* (cat. 3). Another theme started to become clear to me. I loved industrial images–gritty, with often-heroic workers. My grandfather, an immigrant with little command of English, was a manual laborer at the Fisher Body division of

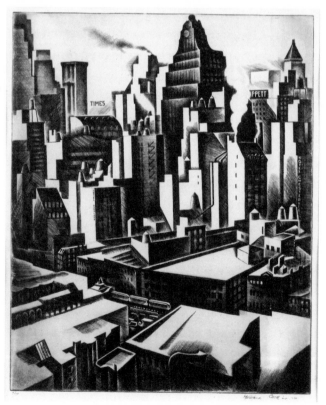

CAT. 2

General Motors in Cleveland. To me he was as heroic as the figures in the prints. As luck would have it, under my own nose in Port Washington, Long Island, was a gallery devoted solely to prints. Ingeborg Gallery, owned by Gert Wirth, became my Saturday afternoon hangout, and Gert and I would talk prints for hours. Many wonderful images came from

him. Cold Spring Harbor Gallery on Long Island, run by the late Dorothy Schneiderman, became another regular stop, and it is hard to even estimate the number of wonderful prints found there.

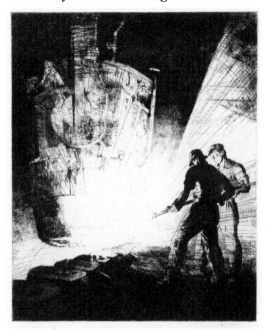

In 1981, Mary Ryan, fresh out of graduate school, opened a gallery on Columbus Avenue in Manhattan. Her first exhibition, of New York night scenes, was reviewed in the *New York Times*. I visited the gallery and that was the start of a wonderful relationship. Mary became a kindred spirit as she quickly perceived that I had an affinity for not only urban landscapes but also social realism of the 1930s.

Collecting prints has been filled with wonderful experiences and surprises pertaining to my relationships with dealers. For example, Mary Ryan knew early on about Gerald Geerlings's *Jewelled City* (cat. 4) being at the top of my wish list. When a couple who were clients of hers wanted a print that I had already purchased from an exhibition, they asked Mary if there was something I might want in exchange. She told them *Jewelled City*, and they happened to have a copy of this very scarce print. The trade was made and I have been eternally grateful.

CAT. 3

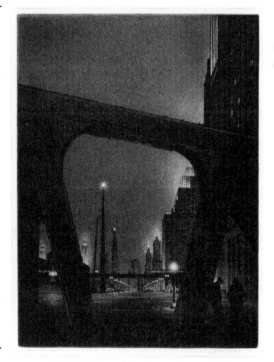

Catherine Burns called me years ago to ask where I had acquired *Jewelled City* after she saw it in an exhibition of our prints. I told her the Mary Ryan wish list story. She asked what was now at the top of my wish list. I told her *Bourbon Street, New Orleans* by Caroline Durieux (cat. 5). Incredibly, she had just obtained

CAT. 4

a copy of this very rare gem in a trade. I never even asked the price; it had my name on it.

I visited Weyhe Gallery several times and each time asked Gertrude Dennis if I could see Louis Lozowick's *Brooklyn Bridge*. The price, more than fair, was still more than my comfort level. Finally, on one visit, she said, "Mr. Cohen, you love that print. Why don't you just buy it?" Of course, she was right, and every time I look at it I silently thank her.

Susan Teller called me cheerfully a few years ago, having found a Clare Mahl print that she knew I wanted and which had eluded me for years. It is one of many from a great friend. Her constant discoveries of interesting material, plus wonderful gallery visits by artists, have endeared Susan to so many collectors.

Another time when I walked into the Mary Ryan Gallery just to say hello, I saw hanging on the wall two Elizabeth Olds prints, *The Middle Class* (cat. 82) and *1939 A.D.* (cat. 83). I was floored! Mary had also introduced me to David Kiehl, the curator of prints at the Whitney Museum. We have spent numerous hours together discussing offbeat images, and he has affirmed my belief in buying the bizarre as well as the classic images.

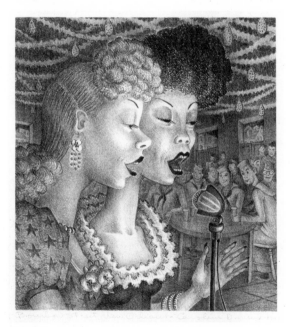

CAT. 5

A fellow collector, Joel Heller, remembered an art gallery that had a group of George Bellows's boxing lithographs from the estate of Senator William Benton of Connecticut. They were in a closet at the gallery, largely forgotten. That was how I found *Preliminaries* (cat. 31).

Ed Ogul, from Paramour Fine Arts in Michigan, contacted me when he discovered a copy of Kalman Kubinyi's *Calla Lily* (cat. 6), a print I loved but had only seen in an old journal. Dr. Lee Stone, a pediatrician/print dealer, understood my addiction and surely fed it with gems. Wayne Kielsmeier, of Covington Gallery in Tucson, has been a wonderful source of images that are difficult to find. As people retired to the Southwest, they sometimes came to him with art bought decades earlier. Such great finds as John Taylor Arms's *West Forty-Second Street, Night* (cat. 12) and Arthur George Murphy's Bay Bridge prints (one example is cat. 63), among others, are in my collection because of Wayne. The adventure goes on!

Walking into The Old Print Shop on Lexington Avenue in Manhattan is like stepping into a time capsule. The Newmans are never too busy to discuss a print or offer great anecdotes.

It was the ability to find so many prints at such seemingly fair and low prices that propelled me into the category of "collector." In a period when the economy was still suffering from the pain of the 1970s, with interest rates and inflation at all-time highs in our country, I had to reconcile the guilt over purchasing what could only be considered luxuries (prints) with the thrill of hanging exciting images on our walls. I rationalized the regular purchases by convincing myself that if I lost my job, I had bought things reasonably enough that I could get my money out. Fortunately, it never came to that.

I suppose I knew I was a collector in 1980 when, having heard me talk so much about prints, my brother and sister-in-law gave me Joseph Pennell's *The Stock Exchange* (cat. 10) for my birthday.

Certain guidelines or rules for my collecting emerged early on. It became apparent that buying almost exclusively from the

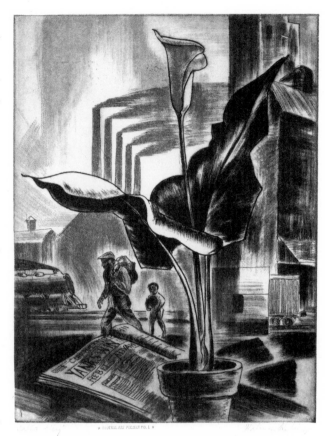

CAT. 6

handful of dealers who specialized in American prints was advantageous. As they got to know me, many of them would contact me with interesting images. This provided me with exposure to so many prints that I would have otherwise never seen. In addition to the dealers already mentioned, Fred Baker, Betty Duffy, Madeline Fortunoff, Esther Sparks, Ellen Sragow, and Rona Schneider were all instrumental in helping me build the collection. I tried to reciprocate by being receptive to their offerings. Another guideline was the decision to focus on black and white images almost exclusively. For the categories to which I was drawn, they seemed most appropriate. Any collector has to have boundaries, or things can spiral out of control. Of course, a few exceptions have crept in over the decades.

So much research and writing about prints have been published over the last fifteen years that it would be fatuous to assume that I am breaking new ground. Rather, I am trying to present exciting examples from the collection. Some will look nostalgic, some will elicit a shaking of the head. But together the prints shown in this exhibition offer a good reflection of a terrific period of change.

*T*HIS PRINT COLLECTION spans the period between the early twentieth century and World War II. Those years were filled with important changes in the United States, including the rise of the city, two world wars, and the Great Depression, and saw major changes in the content of prints in this country.

Urban landscapes was one of the first subjects that captured my interest. Other categories that are represented in the collection and that I became more and more interested in are: daily life, labor and industry, social realism, and satire. Examples of prints that fall into these categories are the focus of this exhibition. I have tried to select examples with visual impact as well as interesting content.

My use of the word "print" refers to a fine art print, as opposed to a modern reproduction. A "fine art print" is created by the artist on a surface, which is then inked and pressed onto paper. The inking and pressing can be done by the artist or a master printer who is supervised by the artist. The artist is involved from start to finish. The number of copies is limited, and the resulting prints are usually signed by the artist.

Printmaking in America, for most of its history before 1900, was used primarily for purposes of illustration in printed works or broad commercial reproduction. Book illustrations and scenes of daily life were made in great quantity with little interest in the identity of the artist (*American Master Prints*, 4). Woodcuts and wood engravings were used widely to illustrate magazines and broadsides and to reproduce maps. Battle scenes, presidents, and birds-eye views of towns were depicted using a variety of reproductive techniques. Between 1835 and 1885, Currier and Ives, for example, created prints of hundreds of scenes with immense popular appeal and affordability for the masses. Their prints documented nearly every important event, every new invention, every type of activity in that 50-year period. The prints, however, were not signed or supervised by the artist, and usually were copied from paintings. They were produced in huge numbers, depending on public demand. These are called "prints" but by definition are not "fine art prints." However, collectors today prize many of them for their ability to narrate an important period in our history.

One of the earliest catalogues of the work of American engravers and prints covering the period from colonial days until 1900 was compiled by David McNeeley Stauffer in *American Engravers upon Copper and Steel*, published by the Grolier Club in 1907. In Carl W. Dreppard's 1930 book, *Early American Prints*, he calls Stauffer's book the definitive reference book for early American prints. Dreppard's book is itself a good summary of printmaking prior to the twentieth century. This is interesting background

information, although the prints in my collection were made mostly after the period covered in Stauffer's book.

This collection includes prints executed using a wide variety of techniques, including etching, woodcut, wood engraving, linoleum cut, aquatint, and lithograph. Each has its distinctive appearance, but all share in common the characteristics of the artist's individuality. There is no one favorite technique; many artists specialized in one of the processes. Intricate, often beautiful examples of each can be seen in this exhibit. There are very few color prints in the collection. As I learned more about the art of the 1930s, I felt the Great Depression was better expressed in black and white.

Despite many advances in printing, prior to the 1920s exhibitions of prints by American artists were primarily limited to etchings. As an example of how long it took for lithography in American fine art to catch on, the Print Club of Philadelphia was considered daring in 1929 when it organized a series of exhibitions exclusively devoted to lithographs. Yet, artists as notable as George Bellows, Joseph Pennell, and Childe Hassam were making fine lithographs during the 1910s and '20s.

A note about lithography as an art form is worth mentioning. Whereas etching is done by incising or engraving lines and tones on a metal plate, lithographs are made by drawing on a prepared stone with a greasy crayon. It allows for a freer hand in drawing and more spontaneity. In 1896, the Grolier Club mounted a comprehensive exhibition of lithographs by some European masters. Louis Prang, whose American company published popular lithographs copied from artists' paintings, hoped that American artists would embrace this process. However, commercial printing companies in the United States were reluctant to divert resources to printing for artists' limited editions. In 1914, an American artist, Albert Sterner, became frustrated with trying to print his own lithographs. Through the American Lithographic Company, he was referred to a young printer, George Miller, who had served an apprenticeship. Two printers, Bolton Brown and George Miller, became interested and skilled enough to allow artists to experiment with lithography (Adams, vii–viii). Before becoming an expert lithographic printer, Brown had a long and successful career as a teacher, painter, scholar, and critic. At the age of 50, intrigued by artist Albert Sterner's exhibits of lithographs in 1915, he immersed himself in the study of lithography and, in 1919, began to print for artists other than himself (ibid., 28–31). George Miller was a craftsman who came out of the commercial realm, and attracted George Bellows, who liked the artistic effect of lithographic images. Bellows is thought to be the first important artist to create scenes of American life through the use of the lithographic stone. *Preliminaries* (cat. 31), a 1916 lithograph, is in this show. In 1917, Miller opened a small shop in New York, the first lithographic workshop in America for the sole purpose of providing printing services to artists (ibid., 28). He was soon overloaded.

The lithographic process for fine art was difficult to achieve successfully. The process was "touchy" and required expert handling. When Miller temporarily left for the Navy, Bellows switched to Bolton Brown as his printer but George Miller went on to a very successful career and was popular with artists working with lithography well into the 1930s. Many of those prints are dedicated to him. It was not until the 1930s that lithographs became the medium of choice for American artists.

Urban Landscapes

THE NEW YORK ETCHING CLUB was founded in 1877 by American artists who mainly were established painters. They wanted to create limited edition original art that was a departure from mass-produced lithographs, such as the Currier and Ives prints. In addition, with etching as opposed to lithographs, artists could create images without unwanted reworkings or modifications by printers in the trade. Charles Mielatz, who was elected as a member in 1890, appears to be the first American etcher to focus his efforts not on pastoral or popular narrative scenes, but rather on structures or localities of the city that interested him. He chronicled many buildings, structures, and scenes of New York, experimented with various printing techniques, and became the Instructor of Etching at the prestigious National Academy of Design.

CAT. 7

His 1891 print, *In the Bowery* (cat. 7), combines a view of a streetcar, the elevated train, background buildings, and people walking on a rain-slicked street. This is one of Mielatz's earliest urban views, and for several years, he was the major artist to successfully portray the buildings of the metropolis. His *Wall Street, New York City,* 1892 (cat. 8), was another early image of important structures. *High Bridge on the Harlem River* (cat. 9), done many years later, shows his ongoing interest in the architecture of New York. Mielatz is represented in many museums, but has not gotten the recognition one might expect given his importance in the evolution of contemporary printmaking. He was often striving for new and interesting effects in his prints. He was a strong proponent of early twentieth-cen-

14

CAT. 8 CAT. 9

tury printmakers, encouraging them to show their works at the National Academy or American Watercolor Society exhibitions. I continue to look for good examples by him to add to the collection.

Joseph Pennell had left New York in 1884 to settle in London. Upon his return in 1904, he was amazed by the changes. Financial, commercial, and industrial firms had become dominant. He considered New York City to be man's greatest achievement, being captivated by its skyscrapers and the "magnificence of man's labors on such a grand scale" (Bryant, preface).

If Europe's interesting architecture was represented by churches, America's was skyscrapers. Pennell was not interested in the human condition, such as Sloan, Luks, Glackens and Bellows later showed in their art. Rather, along with Mielatz at the turn of the century, he recognized in the industrial and commercial environment a subject matter expressive of a modern age. As he wrote in his article in the *Journal of the Royal Society of Arts*, "The Unbelievable City, the city that has been built since I grew up, the city beautiful built by men I know, built for people I know. The city that inspires me, that I love" (111). Pennell spent many years abroad, returning intermittently. On his last return to the States, he became aware of the interest in American prints by the Library of Congress, and he became a benefactor. The Pennell Fund for acquisition of American prints was established upon his death, and after his wife died, his own prints and

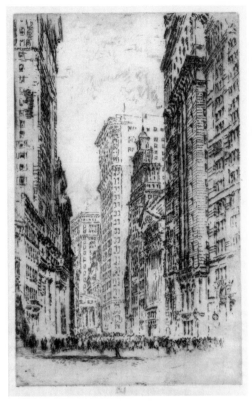

CAT. 10

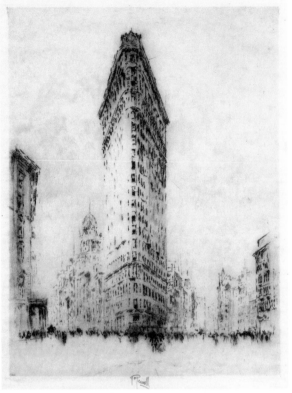

CAT. 11

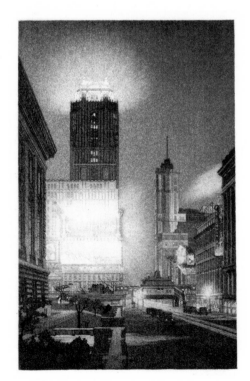

CAT. 12

drawings, his collection of Whistler prints, and other prints by important artists owned by him, were left to the Library of Congress (Beall, vii–viii).

Two prints by Pennell, *The Stock Exchange* (cat. 10) and *Flatiron Building* (cat. 11) present beautiful images of iconic structures. In Pennell's etchings, the humans are miniscule and undifferentiated, accentuating the imposing buildings. Mielatz, in contrast, incorporated people as an important part of the city.

Both Mielatz and Pennell received commissions from the Society of Iconophiles, which was founded in 1894 by William Loring Andrews, a founder of the Grolier Club. Its stated mission was to issue a series of engraved views of New York City and portraits of prominent

individuals associated with New York City. There were ten members originally, and each series was to have an edition of 101 copies. The members each kept one, and the rest were sold to the public. Sixteen series of prints were published between 1895–1929. Their engravings were done with the purpose of preserving images of the landmarks. They preferred the etcher's pen to photographs. Interestingly, both Mielatz and Pennell, in their series for the Society, did lithographs as opposed to engravings. The printing, however, was done in London, not in America (Minutes: Society of Iconophiles of New York 1895–1909, from the Library of the Grolier Club). In my opinion, Pennell's lithographs from that series are not nearly as interesting nor of the high quality as his etchings done during the same period. Four of the members of the Society apparently felt the same and returned the series.

John Taylor Arms, like several subsequent artists, was trained as an architect, and, taking up etching as a hobby, became obsessed with achieving jewel-like etchings. He kept records of how many lines he drew and etched each day. He made dozens of exquisite and complex etchings of churches and gargoyles, but I regard his handful of urban scenes as among the greatest artistic achievements of American printmakers. He was inspired by the beauty and engineering feats of the Brooklyn Bridge, the buildings and skyline of New York, and the activity along Midtown streets.

A close inspection of his prints will reveal his painstaking skill. And though the technical virtuosity is evident, the great New York images take on a dimension of overall beauty, and the ability to elicit gasps on first glimpse. The image of *West Forty-Second Street, Night* (cat. 12), which I first saw at the National Collection of Fine Arts, haunted me, and it was

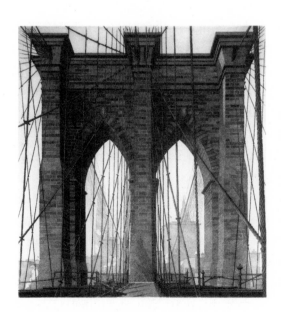

CAT. 13

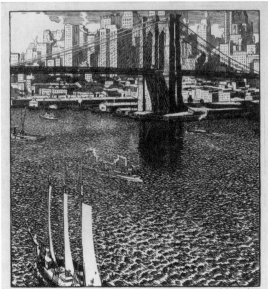

CAT. 14

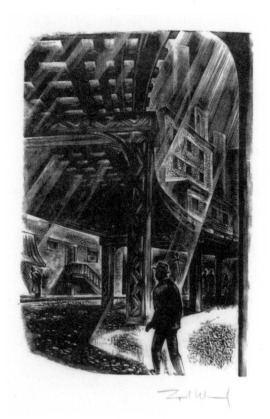

CAT. 15

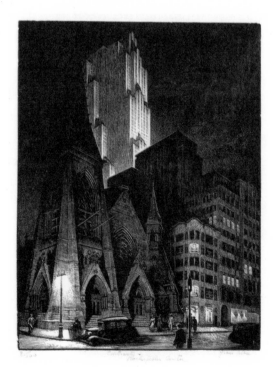

CAT. 16

at the top of my wish list for thirty years. The ability to achieve blasts of light from billboards and building tops was both stunning and unprecedented. It was printed in blue-green ink, as opposed to a similar print done as a day scene.

In addition to his printmaking, Arms was an ardent advocate for his fellow artists, purchasing many of their prints during the Depression. He was the leader in print clubs and art societies, continually worked to stimulate interest in art among youth groups, and was a judge in many print competitions. His New York prints brought him together with Mielatz and Pennell as artists who were fascinated by the city. *The Gates of the City* (cat. 13) shows a frontal view of the Brooklyn Bridge with the complex cables and brickwork attaining an incredibly detailed majesty. *West Forty-Second Street, Night* (cat. 12) has a dazzling light achieved through the use of etched lines and space that sets it apart from the work of Arms's contemporaries.

A different technique and a different perspective of the Brooklyn Bridge were achieved by Rudolph Ruzicka (cat. 14). His crisp woodcut image is "heightened by the flat white sails of the passing ship, the white caps and dramatic light" (*Image of Urban Optimism*, 14). He was one of the earliest of the twentieth-century American woodblock artists, and produced many scenes of the rivers and harbors of New York.

Lynd Ward made a series of wood engravings depicting the experience of living in the 1930s. In *Under the El* (cat. 15), Ward offers a completely different view of the elevated grid from what Mielatz depicted much earlier. This 1937 wood engraving is from *Vertigo*, one of Ward's books in which the woodcuts alone told the stories. A wordless novel, *Vertigo* is considered to be his masterpiece. Published in the midst of the Great Depression, it dealt with financial

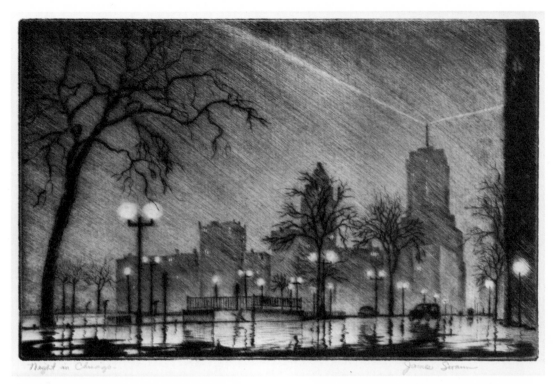

CAT. 17

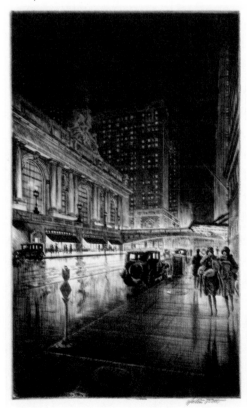

CAT. 18

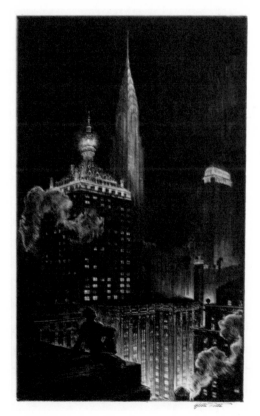

CAT. 19

CAT. 20

instability, debt, and joblessness. Ward earned many prestigious awards, including one from the Library of Congress.

Grace Albee was one of the first women to be elected to the prestigious National Academy of Design. She produced many finely-drawn rural scenes in which she depicted abandoned buildings or farm implements (Seaton, 87–88). But *Contrasts-Rockefeller Center* (cat. 16) is an urban landscape using delicate wood engraving with a night setting to achieve a luminous view of the RCA building in Rockefeller Center rising behind a street scene with its own complexity. I am constantly struck by the ability of Albee and other artists to achieve such dramatic effects of light.

Gerald Geerlings was another trained architect who became enamored of creating meticulous urban images. *Jewelled City* (cat. 4) won the Gold Medal at the Pennsylvania Academy of Fine Art in 1931. It is a Chicago scene, done in the depths of the Depression, with strong contrasts between the broken-down citizens in the foreground, and the jewel-like twinkling lights along the distant street. Geerlings invented a technique using aquatint where the acid obtains a graduated effect echoing nocturnal light sources. He experimented often to achieve this heretofore unknown effect. Unlike Edward Hopper, his work does not necessarily seek to evoke psychological or contemplative qualities. His works are characterized by extreme detail and a rich variety of tonal gradations and surface texture. I regard this as a landmark print because of its ability to repeatedly intrigue

the viewer. The city is indeed a series of jewels! (See Foreword for a description of the circumstances leading to my acquisition of this great and very scarce print.)

James Swann's drypoint etching, *Night in Chicago* (cat. 17), demonstrates, as does Geerlings in *Jewelled City* (cat. 4), that Chicago landscapes could be as fascinating as those of New York. This was Swann's presentation plate for the Chicago Society of Etchers (Reese, 196). Moist, wet, glistening pavement, and an array of lamps, give this landscape a romantic quality. Many printmakers of the period achieved wonderful atmospheric effects—rain, snow, light. I have a particular affinity for prints that achieve a "wet" effect of rain or snow.

Most of Walter Tittle's graphic work consists of portraits of celebrities, including Franklin Roosevelt, George Bernard Shaw, and Justice Holmes (Reese, 201). However, in these

two night scenes, *Grand Central Night* (cat. 18) and *Manhattan Minaret* (cat. 19), he uses contrasts and some artistic license to create wonderful depictions of Manhattan landmarks.

Howard Cook was the first artist whose prints I wanted to accumulate in quantity. *Times Square Sector* (cat. 2) was, for me, an exciting discovery at the Associated American Artists gallery. Seeing his work was like seeing my first Hudson River landscape. *West Side, New York* (cat. 20) came shortly after, and then I acquired several more from Betty Duffy at Bethesda Gallery—all before Cook was "rediscovered." *The New Yorker* (cat. 21) is a good example of his woodcuts of towering buildings.

Like many printmakers, Cook studied etching at the Art Students League under Pennell. He began exploring the woodcut as he settled in Taos, New Mexico, in 1926–1927, where he met and married Barbara Latham, also an accomplished printmaker. They both did scenes of the Southwest that give a good flavor of pueblo life. In 1928, they drove to New York City and became friends

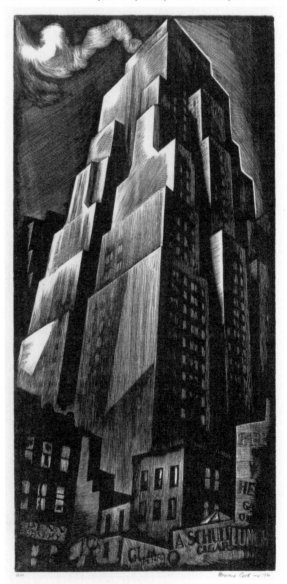

CAT. 21

21

with Carl Zigrosser, then director of Weyhe Gallery. In the late '20s and early '30s, Cook was taken with the mammoth structures of the city and did several extraordinary monumental etchings and woodcuts of landmark buildings. In January 1984, the National Collection of American Art, now the Smithsonian American Art Museum, mounted a major retrospective exhibition of his graphic art.

Janet Flint, in Duffy's catalog raisonné of Cook's work, wrote that by World War I, a national pride had emerged. Exciting symbols of industrialized America became fertile subjects, including factories, skyscrapers, steel mills, subways, bridges, and the "Human Pageant" of New York City. But Cook, while sharing common interests and images with contemporary artists, retained his own personal expression. There is no mistaking his urban prints for those of anyone else. He thrived on new experiences and challenges, thus the diverse body of work (Duffy, 33–34). While I have focused on urban landscapes, I love his rural and World War II images as well. His portrayals of exhausted GIs or lines of displaced refugees are strong.

Just as Hudson River painters were drawn to the West and its canyons, waterfalls, and

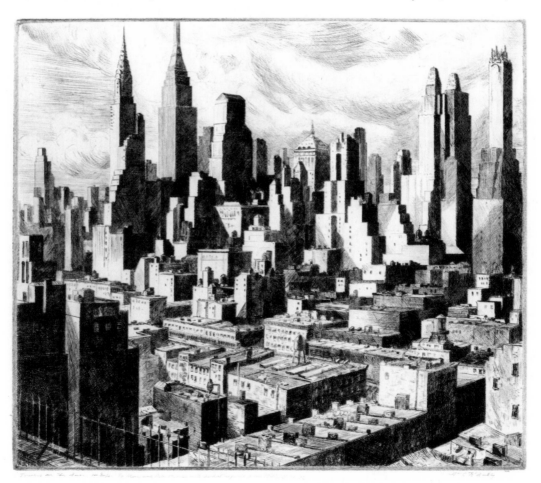

CAT. 22

22

mountains in the second half of the nineteenth century, so were American printmakers drawn to the man-made canyons and urban wonders of the 1920s and '30s. William McNulty's *Towers in the Sun* (cat. 22), Samuel Margulies' *Man's Canyons* (cat. 23), Armin Landeck's *Manhattan Canyons* (cat. 24), Howard Cook's *West Side, New York* (cat. 20) and *Times Square Sector* (cat. 2), and Arnold Ronnebeck's *Wall Street* (cat. 25) are concerned with the light and geometric forms of Manhattan commercial hubs. Rather than simply recording buildings, the artists put their own stamp of originality on each print.

An interesting juxtaposition can be seen in Edward Hopper's *Night Shadows* from 1921 (cat. 26) and Armin Landeck's *Pop's Tavern* from 1934 (cat. 27). Both show a perspective at night

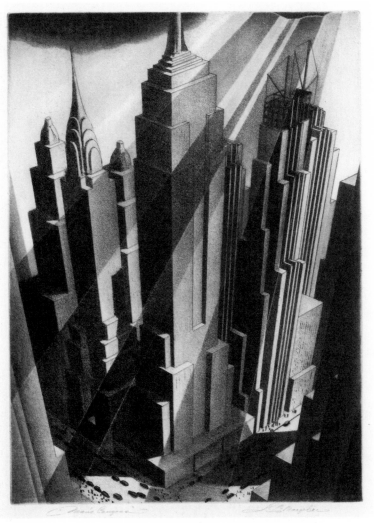

CAT. 23

from a second story window. Hopper's depictions of quiet solitude and psychological loneliness have been discussed repeatedly in various exhibitions and essays. Landeck, a master printmaker, though not nearly as well-known, captures the same mysterious feelings in this print. Both artists chose birds-eye views at what would appear to be late at night. The city of bright lights and bustling activity is not found in these thoughtful, contemplative images. In *Pop's Tavern*, perhaps the bar offers a little respite from the loneliness of the night. (Like Geerlings and Arms, Landeck had trained as an architect.) Landeck's early prints became extremely popular with collectors during the 1980s and 1990s, triggered by exhibitions of his extensive body of work by Associated American Artists and June 1 Gallery.

As an aside, Hopper, like John Sloan earlier, had difficulty selling his works. *Night Shadows* (cat. 26) was part of a portfolio of six prints by various artists to be offered with a year's subscription to *New Republic* magazine, all for $9.00 (Watrous, 63). Hop-

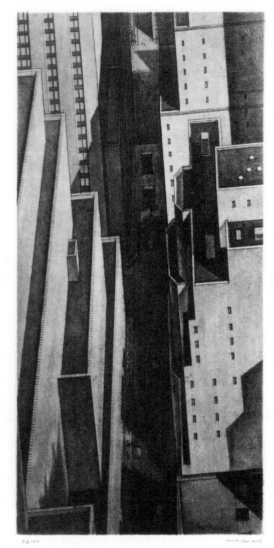

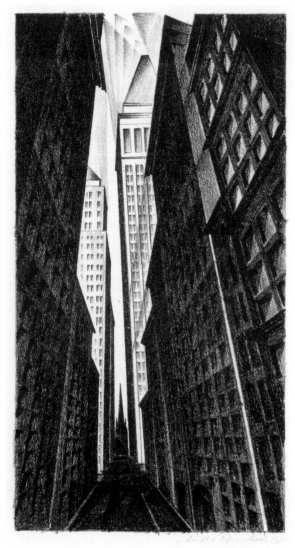

CAT. 24 CAT. 25

per did several etchings, and credits that work with helping to give him the confidence to subsequently paint in his unique, provocative style (Goodrich, 22–27).

Anton Schutz chronicled buildings of New York throughout the 1920s and '30s. I had seen dozens of his etchings, but felt they lacked the interesting touch that Pennell had brought to similar subjects earlier in the century. Then, his aquatint of *The Great White Way* (cat. 28) surfaced at Harbor Gallery and it was like discovering an entirely new artist. Executed in 1929 while the economy still seemed vibrant, it captured the lights, theaters, the Times building, and overall vibrancy of Broadway in a way not previously drawn.

Mary Ryan obtained the estate prints of James Allen from his daughter and did a major exhibition of his work in 1984. Allen was an established illustrator for popular

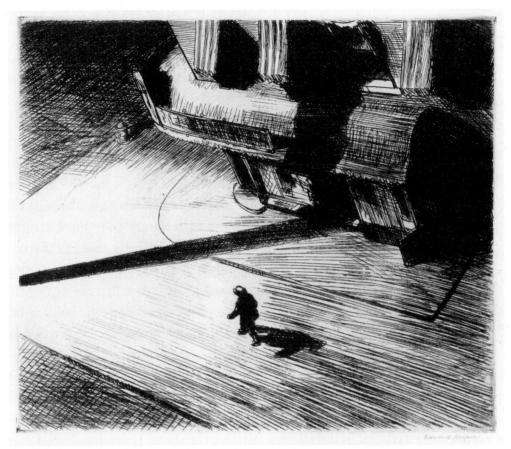

CAT. 26

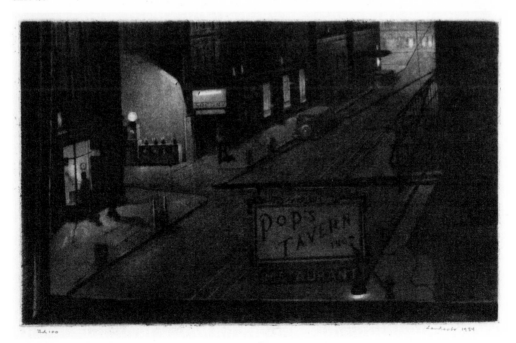

CAT. 27

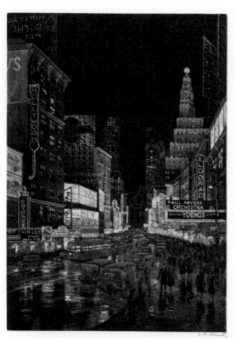

CAT. 28

magazines before World War I. He became a fighter pilot in the war, and afterwards began to experiment with printing techniques. His etchings began to win awards, and he was, and is, regarded as a luminary of American print-making.

The print of James Allen's *Planes Over the Statue of Liberty* (cat. 29) seems to be the only known impression. It is a patriotic expression by Allen during a period of great anxiety in the world, and uncertainty over the U.S. role in the European War. The Statue of Liberty was portrayed in prints by several artists during the 1920s and '30s, usually dramatically lit or positioned. This one is powerful because of the symbolism. It was reproduced in the *Saturday Evening Post* on October 25, 1941.

The prints in this Urban Landscapes section document the transition from old to new urban centers. The 1920s saw a construction boom in cities, as prosperity seemed assured. Mielatz and Pennell, and then Arms and Ruzicka, were capturing the excitement of the new twentieth-century city. In the next few decades, Geerlings, Lozowick, Cook, Landeck, Margolies, and Allen, were drawing interpretations of grand new skyscrapers.

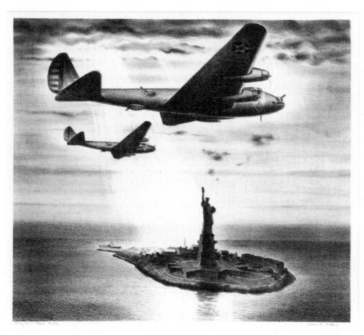

CAT. 29

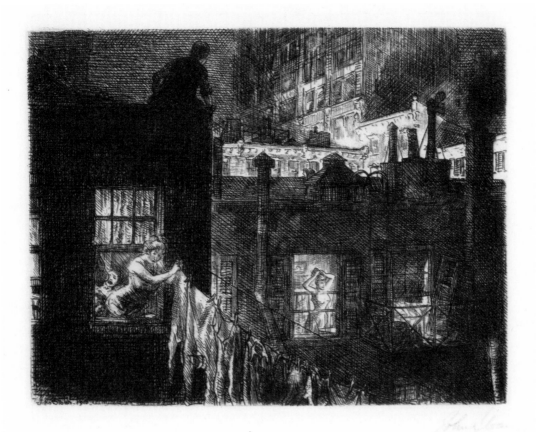

CAT. 30

Daily Life

AT THE SAME TIME that Mielatz and Pennell were beginning to show the strength and beauty of the new structures of New York, some artists began to create prints that portrayed people in their daily routines. They could be working, enjoying leisure time, hanging out laundry, having meals, or traveling. The prints could show grand times or depict sheer exhaustion by people in subways in the wee hours.

By 1900, the rapid and unregulated growth of the largest cities created complex problems. Housing, disease, crime, education, poverty, and increasing inequality issues were part of a new American experience. John Sloan was early in capturing the societal changes in his art; even more dramatic portrayals were to come a few decades later from a wide variety of artists.

Early in the twentieth century, works of foreign masters dominated collectors' focus. A few American printmakers came up with fresh conceptions. Standard rigid practices came into question by progressive artists. John Sloan is the first American artist to couple liberal social and political attitudes with prints depicting actualities of con-

27

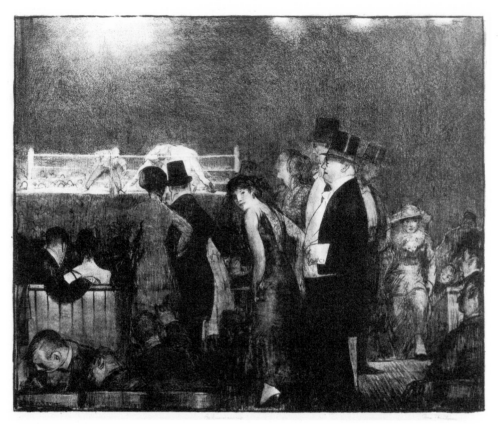

CAT. 31

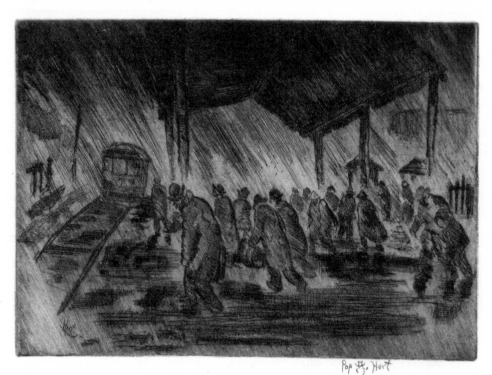

CAT. 32

temporary urban life. He had been a newspaper illustrator and taught himself the craft of etching. In 1905–1906, he created the ten "New York City Life" prints. They were genre scenes of daily life of New York City dwellers. Some of his prints were dismissed as "vulgar" by conservative critics, though by today's standards they were tame, even playful. Sloan became known as part what was later called the "Ashcan School," a group of artists who portrayed in paintings, prints, and drawings the alleys, tenements, and immigrant dwellers of New York. Robert Henri, a well-known artist and the leader of the Ashcan School believed the artist should address what he could get to know personally. One didn't have to sweeten a print to make it beautiful.

The print *Night Windows* (cat. 30) shows a husband sneaking a peak at an attractive neighbor while his wife is busy hanging laundry. It was included in the 1913 Armory Show, which is credited with shocking and transforming American views of art by breaking with conservative traditions. Today, Sloan's prints are prized for their wonderful portrayal of real life in the city. However, in his day, sales were scarce, possibly because of the subject matter. Having invited Sloan to participate in the American Watercolor Society show at the National Academy of Design in 1906, Mielatz was embarrassed and Sloan was outraged when the exhibit of his New York prints was met with derision by conservative critics (Watrous, 45).

George Bellows, an enormously successful painter, did several lithographs depicting current customs, dramatic events, or leisurely diversions. He also disliked what he considered to be religious hypocrisy, and created images that pilloried it. Among his most successful and popular prints were those depicting prizefights, such as *The Dempsey-Firpo Fight* and *A Stag at Sharkey's*. The print in this exhibition, *Preliminaries* (cat. 31), places the action in the ring in the background, with finely-dressed "upper-class" people getting seated for the main event.

As discussed in the Introduction, prior to Bellows working in lithographs, etching was the preferred method for creating fine prints. Lithography was regarded as a commercial medium best suited for mass production. For Bellow and many artists after him, the ability to create the feel of drawings with their spontaneity was important.

George Overbury "Pop" Hart was peripatetic. His images from Mexico and the West Indies presented the color and liveliness of cockfights, fiestas, and markets. *Working People* (cat. 32) is different in that it portrays a dreary day with people heading off to the daily grind.

Levon West's *Rainy Day* (cat. 33) is another departure from an artist's usual work. He etched many lively images of rugged outdoor life in the West, filled with packhorses, dog teams, Native Americans, and mountain rangers. I particularly like the way he handles rain on a New York street.

Asa Cheffetz was a master of wood engraving as evidenced by numerous awards, and by

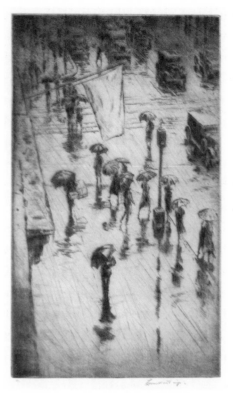

CAT. 33

being chosen to design the official bookplate for the Library of Congress. His scenes of New England beautifully capture nuances of light, shade, and reflections. *Monday (The American Scene)* (cat. 34) was one of the first prints on my wish list. It is hard to imagine tenements with laundry hanging from clotheslines looking more lyrical.

Regarded by many observers and critics as the finest printmaker of the first half of the twentieth century, Martin Lewis captures the spirit of daily life in ways that leave indelible memories on viewers. *Quarter of Nine, Saturday's Children* (cat. 35), done in 1929, shows fashionable young women going to their Saturday jobs at department stores. The title derives from a nursery rhyme. Lewis printed this in brownish black to produce a warmer effect, with sun streaming down. Paul McCarron's catalog raisonné notes that Lewis, while brilliantly capturing snow-cov-

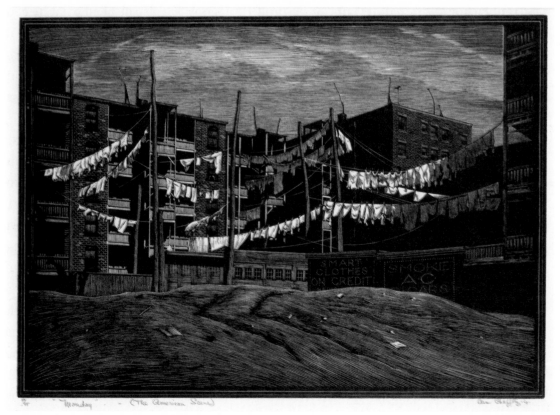

CAT. 34

ered stoops or rows of tenements glistening in rain, was more concerned with people absorbed in their daily tasks of living: working, playing, or drawing.

Day's End (cat. 36), produced in 1937, may be seen as a contrasting companion piece to *Quarter of Nine, Saturday's Children.* The scene of factory workers shuffling home at the end of the day was made eight years later, and deftly reflects the mood change in the country from the earlier pre-Depression piece.

Most New Yorkers will fondly remember the popularity of the Automat, where people could get affordable meals in a cafeteria setting by putting coins in a window slot. Don Freeman, an illustrator and author of numerous children's books, is noted for his depictions of New York city scenes, particularly of theater-goers. His *Automat Aristocrat* (cat. 37) is a good reminder how eating "like a king" was not restricted to royalty.

The subway was the preferred mode of transportation for many New Yorkers. Inexpensive, efficient, and available at all hours, it proved a good subject for

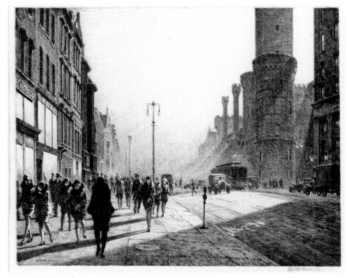

CAT. 35

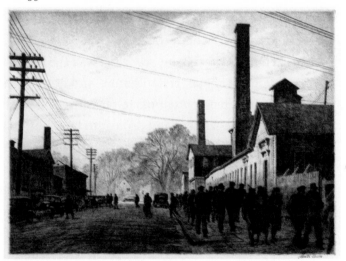

CAT. 36

many artists. Ida Abelman was raised in a family of socialists who identified strongly with the working class. *Wonders of Our Time* (cat. 38) is a light-hearted look at the "simple" act of getting to the workplace. Isac Friedlander's *3 A.M.* (cat. 39) depicts some pretty tired folks, plus a couple necking off to the side. The advertising poster emphasizes a fresh product, an interesting contrast to the far-from-fresh passengers.

William E. Smith was one of several African-American artists to portray the "American Scene" from the perspective of people who migrated from the South to try to find manufacturing jobs. *Poverty and Fatigue* (cat. 40) is a good example of his work. Smith studied art at the Karamu House in Cleveland, a city which, like Detroit, was dominated by manufacturing. Karamu House was an interracial hub designed to offer theater and art for the black community. Under the WPA/FAP, it attracted several artists (King-Hammond, 7–8).

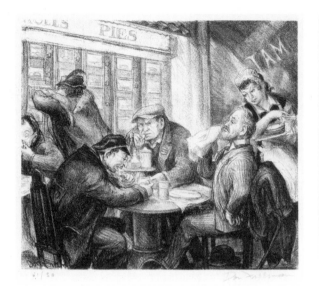

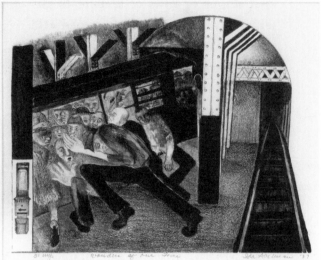

CAT. 37

CAT. 38

Farms in the 1930s suffered enormously from drought, dust storms, and collapsing prices. There was, however, a thread of American art that was rooted in the soil. Thomas Craven, an art critic, was the biggest booster of the idealistic images by Grant Wood, Thomas Hart Benton, and John Steuart Curry. The numerous prints could be interpreted as attempts to reassure a badly shaken society. The images were in contrast to the pessimism and protest to be found in the social realism of the East Coast artists. Grand Wood's *In the Spring* (cat. 41) is representative of this regional movement.

During the Great Depression, the Civilian Conservation Corps was a pet project of President Roosevelt to put many men to work in the woods doing various projects. Friedolin Kessler in his *Hey Look* (cat. 42) portrays a spare moment of unrestrained ogling by the workers in one of the camps (Allen, 117).

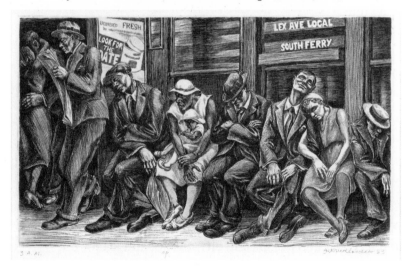

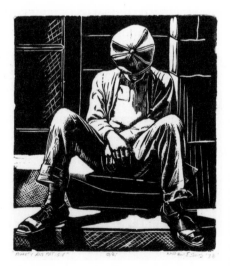

CAT. 39

CAT. 40

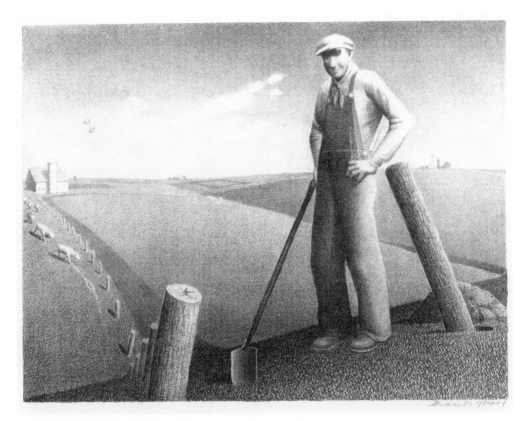

CAT. 41

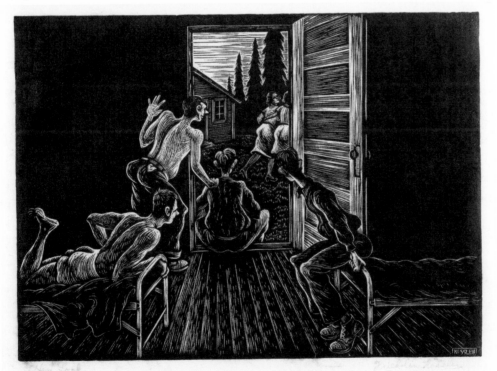

CAT. 42

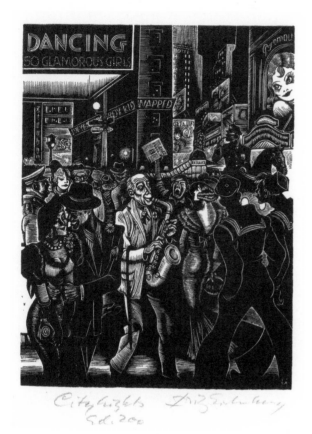

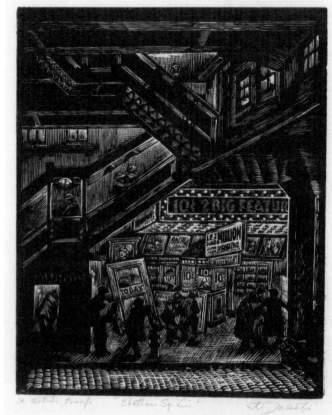

CAT. 43

CAT. 44

Fritz Eichenberg and Eli Jacobi demonstrated what might at first appear to be sharply contrasting views of life in New York. Eichenberg, who became well known for his new editions of classic books, did a handful of wood engravings of city life. His *City Lights* (cat. 43), at first glance, looks like a happy night life image. Closer inspection reveals a sense of bawdiness and cynicism. No person seems happy, despite being out on the town.

Eli Jacobi had successfully established himself as an illustrator for many popular publications. The Depression hit him hard, and he wound up living in the Bowery, a street of downtrodden men. He did get support from the Federal Arts Project of the WPA in 1935, and he began to document in linocuts the gamut of existence. In World War II he spent thee years in the Pacific, and later did a series of prints documenting the war. As with his Depression images, he demonstrated graphically the human ability to survive the most devastating conditions. Unlike Eichenberg, he did not portray a cynical outlook on life but rather one of camaraderie to help survive. *Chatham Square 'L'* (cat. 44), *Mills Alley* (cat. 45), and *East of the Bowery* (cat. 46) are representative of his work in the Bowery.

34

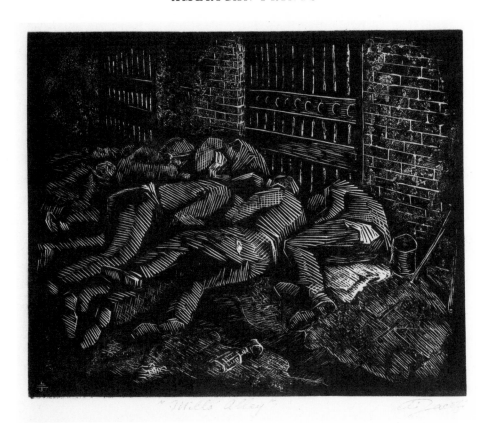

CAT. 45

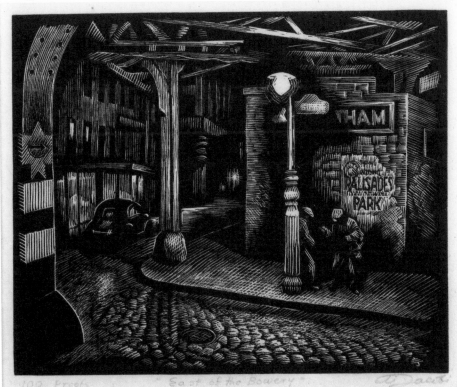

CAT. 46

The Mission (cat. 47) by Raphael Soyer illustrates how, in the 1930s, scenes of daily life morph readily into what we call social realism. In his memoir, he wrote that he believed his art should describe and express people, their lives, and their times. He fell in love with work by Sloan, Henri, and George Luks of the Ashcan School because they dealt with every day common people with their humble, hard lives (Zigrosser, 58). His subjects are treated with compassion and understanding of the forces out of their control.

Don Rico, *Home Relief Bureau* (cat. 48), and Maxine Seelbinder, *Housing Needed* (cat. 49), used a mural format to illustrate the daily toils confronting people. The figure at the top of Rico's print suggests the possibility of an optimistic outcome. Seelbinder's print has an unrelenting pessimism, and I am struck by the edition size of only seven, indicating a belief on her part that this image was too grim to be widely distributed or purchased.

Finally, Caroline Durieux's *Bourbon Street, New Orleans* (cat. 5), is a delightful print of a domestic scene during World War II with singers performing for GIs. "Durieux's lithographs of Louisiana subjects stand as some of the most compelling socially satirical prints of the 1930s and 1940s" (Seaton, 122). From 1939–1941 she directed the Louisiana WPA-FAP and later served as printmaking instructor at Louisiana State University. *Bourbon Street* was issued during World War II in an edition of only ten, and I had almost given up hope of finding one.

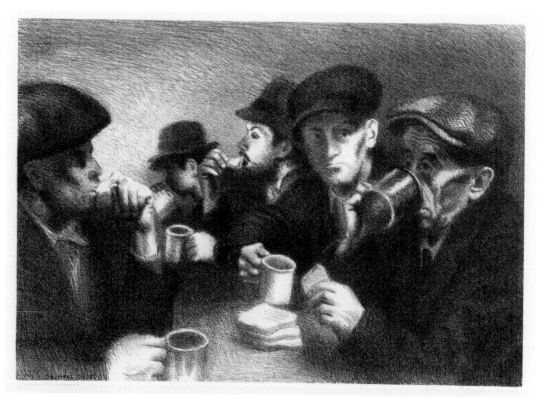

CAT. 47

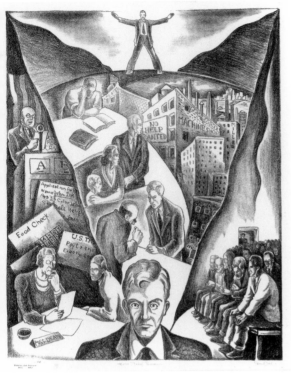

CAT. 48

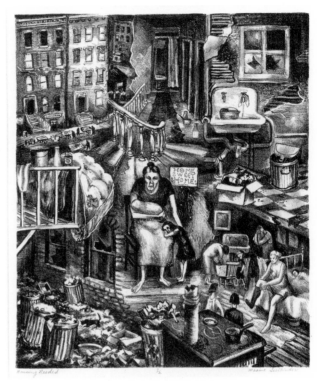

CAT. 49

One of the joys of collecting is finding a fascinating image with relevance by a lesser-known artist. *Prohibition* (cat. 50), by G. E. C. Wiggins in 1930, humorously depicts the fallout from a highly controversial, unpopular, and often surreptitiously ignored law. Wiggins later became an instructor at the Pennsylvania Academy of Fine Arts, but in 1930 he was working at an advertising agency.

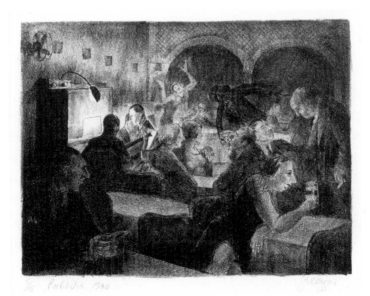

CAT. 50

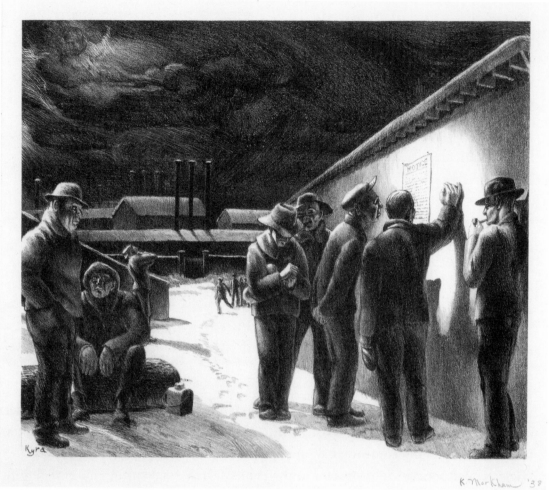

CAT. 51

Labor and Industry

THE FASCINATION, ADORATION, AND ARTISTIC RENDERING of the skyline early in the century by Mielatz, Pennell, and Arms were reflective of its unique contribution to world architecture (Morison and Commager, 299). The skylines showed imposing dignity and beauty, and artists rendered them in many manners.

Coupled with the growth and complex social problems of cities, the buildings, bridges, and roads did create many jobs. The rise of the steel and automobile industries provided jobs for thousands, but also gave rise to labor issues. Strikes, pressure for better working conditions, and sometimes brutal reactions by management, were fertile grounds for commentary by artists generally sympathetic to workers. Portrayals tended to glorify the workers, whether they were heroically working on girders high above the city below, or flashing bulging muscles while doing the dirty work on the ground or in mines.

38

By 1932, after three years of economic contraction, the country was suffering from 25% unemployment. Franklin Roosevelt swept into office. He set forth a comprehensive program of reform and recovery, a "new deal" for the forgotten man. Taken as a whole, the New Deal legislation created more effective regulation over banking, improved the status of farmers and laborers, and led to more equitable distribution of wealth. But it created fears of dictatorship and class antagonisms. Parts of it conflicted with the Constitution (ibid., 580–587).

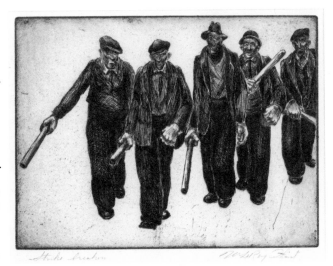

CAT. 52

The National Recovery Act of June 1933 (NRA) was designed to speed up industrial production, spread employment, raise wages, eliminate child labor, and give labor the right to organize and strike (ibid., 595–597). It was, according to Roosevelt, the "most important and far-reaching legislation ever enacted by the American Congress" (Allen, 120). For a year or so, the medicine seemed to work. Unfortunately, it is fair to say that by 1935 the program proved unpopular with almost all factions, for a variety of reasons. Business resented government control, consumers were outraged at price increases, and labor was disappointed by the

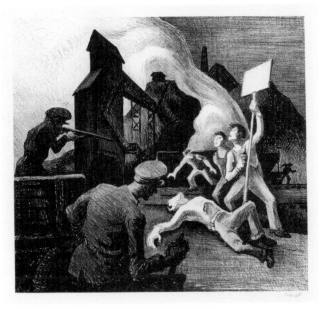

CAT. 53

failure of the programs to deliver on promises. William Randolph Hearst, in newspaper advertisements, attacked the NRA as absolute socialism and a menace to constitutional liberties. Strikes by workers were too common. The Supreme Court unanimously declared it unconstitutional on the basis that it gave unfettered legislative power to the president. What should not be overlooked, though, is the basic decency of the attempts to better the lives of the people of a struggling nation (ibid., 100).

Labor had suffered reverses even during the more prosperous decade of the twenties, but the Depression made it worse (ibid., 598–602). The NRA had created a Labor Board to settle grievances and mediate disputes between workers and management. Organized labor recovered from its wounds of the prior decade, but employers often

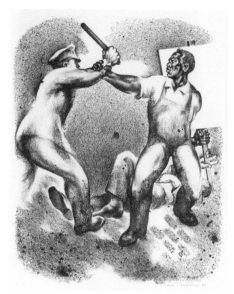

CAT. 54

refused to be bound by the National Labor Relations Board. Strikes and lockouts ensued, and a struggling public felt antagonized by the strikes. There were violent clashes. Congress passed the Wagner Act, which was validated by the Supreme Court in 1937, giving protection to the rights of employees to organize. John Lewis, president of the United Mine Workers, led a new coalition, the Congress of Industrial Organizations (CIO). He helped organize millions of workers and had no reluctance to strike for better wages and conditions. FDR, unlike earlier presidents, did not intervene due to his pro-worker bias. General Motors, on the other hand, had huge power and a generally sympathetic public. Sit-down strikes by auto workers of the CIO lasted forty-four days and managed to be settled without bloodshed as Lewis negotiated with executives. U.S. Steel also caved in to his demands. But peaceful relations did not materialize everywhere. Strikes were met with violence by company "goons" or, as in the case of Republic Steel in 1937, police, who killed ten strikers (ibid., 290–294). An angered President Roosevelt called for "a plague on both your houses," referring to management and labor.

There are several depictions of strikes in this exhibition. Kyra Markham's *Lockout* (cat. 51) was relatively calm, but William Flint's *Strike Breakers* (cat. 52) was ominous.

Thomas Hart Benton was noted for his scenes of daily life in the Midwest. Most were pleasant. "His forms have a restless swinging rhythm that gives his subjects a generalized energy belonging more to the composition that to any one participant" (Taylor, 238). In *Strike* (cat. 53) the image is highly unsettling, as workers' attempts to picket are met with disaster. There is no fantasy here.

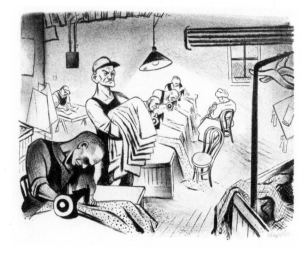

CAT. 55 CAT. 56

40

Louis Lozowick's *Strike Scene* (cat. 54) demonstrates the effort of unions to establish local organizations for black workers. It portrays an African-American protestor trying to protect fallen workers from a violent policeman. Louis Lozowick was one of the best-known printmakers of the 1920s and '30s. His lithographs of cities, bridges, and

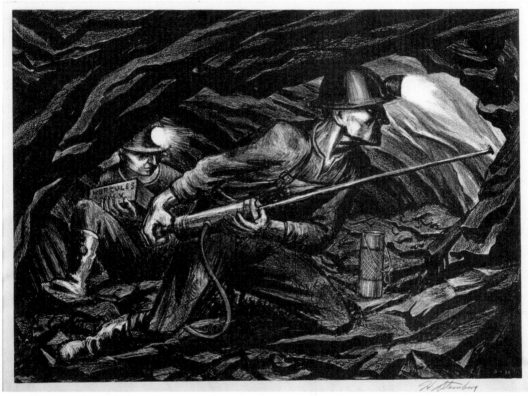

CAT. 57

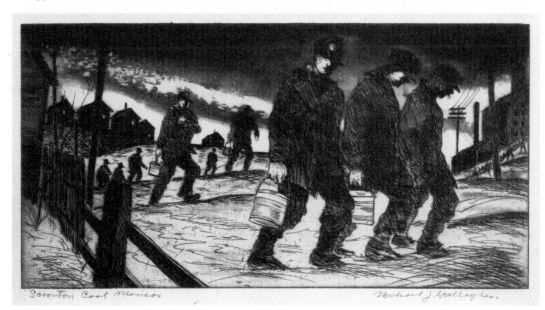

CAT. 58

41

industrial forms were dramatic and often done in an almost abstract manner. His print of the Brooklyn Bridge, a work in the collection but not shown here, was chosen the best lithograph in the Philadelphia Print Club exhibition in 1931. In the mid-1930s he began to inject into his prints his feelings about the socio-economic environment. He showed "Hooverville" in Central Park, shacks set up as living quarters. His compassion was evident in images of lynchings, strikes, and demonstrations. Incredibly, his concern for the working man and desire for social and economic justice for all brought him under questioning by the House Un-American Activities Committee in the early 1950s. The "red scare," a fear of Russia's nuclear might and expansionist policies, led to attacks against artists and film personalities who had expressed leftist sentiments. He was completely vindicated (Flint, 28). He remains one of the most popular artists of the 1920s and '30s.

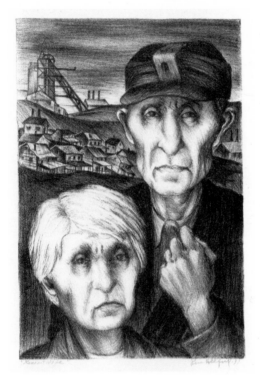

CAT. 59

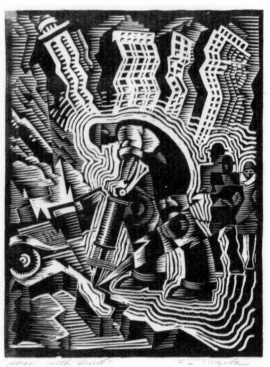

CAT. 60

William Gropper, one of the most powerful social commentators of his time, was one of many artists to portray workers oppressed by management. He was openly communist, though not a party member. *Sweat Shop* (cat. 55) is typical of his art that lashed out at injustice, whether human, social, or political (Reese, 70). In the social realism art scene of the 1930s, Gropper was considered the leading personality.

Workers at their jobs are represented by many prints in the collection. Egleson's *The Factory* (cat. 56), which was on display at the 1939 World's Fair, is like many of the factory scenes. There is a beauty and rhythm to the smoke and workers entering with their shov-

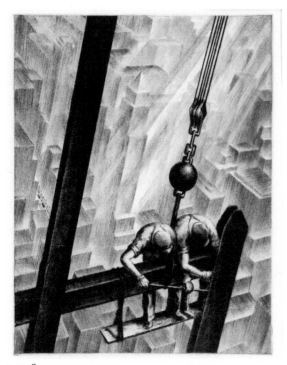

CAT. 61

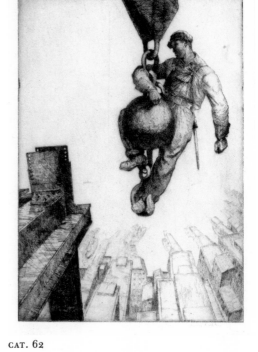

CAT. 62

els. Harry Sternberg's *Forest of Flame* (cat. 1), the first print I acquired, is remarkable for its sense of action. Set in Bethlehem, Pennsylvania, the print shows steel mills in full throttle. The factories dwarf human life and are dramatic and exciting.

Coal mining was essential to both heating and steel making. Sternberg's *Drilling in a Breast* (cat. 57) is a dramatic image of miners at work. It was a print I had seen in 1978 but didn't acquire and always regretted it, until 2007 when I was able to buy it. One of the great things about prints is that, even if it takes thirty years, there is always a chance of finding another copy.

While he saw a strong beauty in the faces of miners and heard the hum of steel facto-

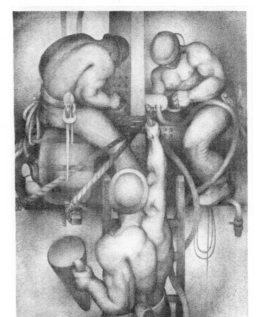

CAT. 63

ries, Sternberg became even more impressed with the courage and dignity of the workers. Sternberg was beloved by students and fellow artists as a passionate humanist. Like many artists in the late 1930s, he was a strong anti-fascist. I learned of his warm hu-

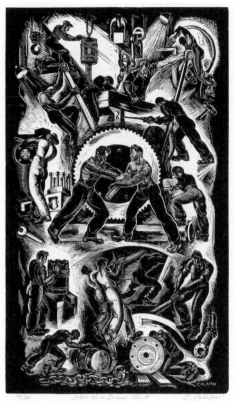

CAT. 64

mor first-hand when I met him at receptions at Mary Ryan's and Susan Teller's galleries.

Scranton Coal Miners by Michael Gallagher (cat. 58) and *Miner and Wife* by Riva Helfond (cat. 59) demonstrate well the tribulations of miners and mining towns. In his print, Gallagher used a carborundum technique for preparing his plates, giving it interesting texture. Within the last decade I met Riva Helfond at Susan Teller's gallery, and asked her how she had made such powerful prints in such a tough environment. She replied, "I just drew what I saw."

Charles Turzak, a Chicago artist, in *Man with Drill* (cat. 60) has the viewer feeling the vibrations from the drill press. Shaking background buildings accentuate the sense of action.

Workers in precarious places, performing heroically, was a recurring theme for artists. Examples include Samuel L. Margolies's *Men of Steel* (cat. 61) and James Allen's *The Skyman* (cat. 62).

Arthur George Murphy resided in San Francisco at the time the Golden Gate and San Francisco-Oakland Bay Bridges were being constructed. According to James Wechsler in the catalog of the exhibition on Arthur Murphy at the Mary Ryan Gallery, Murphy's compositions, epitomizing the portrayal of muscular working men laboring to build America out of the Depression, have their roots in frescoes by Diego Rivera. *Steel Riggers, No. 4, Bay Bridge Series* (cat. 63) is one of his best examples.

Letterio Calapai's *Labor in a Diesel Plant* (cat. 64) draws on the mural concept to show workers in a variety of jobs in a stressful, if not outright dangerous, milieu. I have always gravitated to prints with a mural influence.

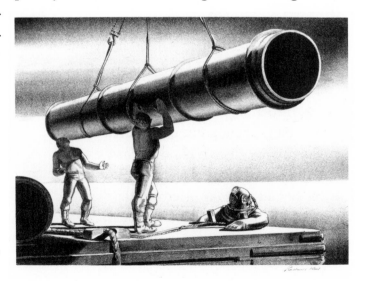

CAT. 65

44

Rockwell Kent was named, in *Prints* magazine in 1936, America's most widely known and successful print maker. He made a series of six lithographs for U. S. Pipe and Foundry that were used in trade publications. *Big Inch* (cat. 65) is one of that series. Kent was another artist with passionate left-wing views, but one would not necessarily know that from his prints. David Kiehl, in an essay for Mary Ryan's James Allen exhibition catalog, contrasts Kent's prints for U. S. Pipe with those of James Allen done a few years earlier. He felt that while Allen's prints have him actively "participating" in the construction, Kent's "have a static and controlled quality, that of an onlooker" (6).

Social Realism

To present a cohesive description of my print collection, I established broad, subject matter categories. In viewing the prints, and in writing this essay, it is obvious that there is a good deal of overlap. Certain prints clearly portray simple daily life without commentary but others beg the difference between artistic observation and artists' renderings of how they see the contemporary social condition. Prints with inherent commentary were a logical extension of the scenes of gritty everyday life by Sloan, Marsh, and Bellows.

It would be hard to imagine a more productive and creative time for American print-making than the 1930s. Ironically, it developed out of economic catastrophe. After the stock market crash of 1929, the art market virtually disappeared. Patronage vanished and galleries closed. Franklin Roosevelt, elected president in 1932, set up a program of public service jobs, conducted by the Civil Works Administration (CWA). This morphed into the 1935 Works Progress Administration (WPA). The WPA was a massive government program to give jobs to nine million people. Three-fourths of the twelve billion dollars in spending went to construction projects, but the WPA also had special programs for writers, musicians, actors, and artists (Wagner, 6–8). Artist George Biddle is credited with convincing the President to include artists in the government support programs (Ryan, 9).

WPA art has become the generic term for art from the 1930s, but not all art done was produced under the auspices of the WPA. There were indeed several programs that paid artists to do their jobs. The PWAP (Public Works of Art Project) was a short-lived program, started in December 1933, that used federal funds to have artists decorate or embellish buildings that were supported by public funds. Artists were selected by committees, and executed murals on public buildings around the country (*The Federal Art Project*, 6–11).

The remaining New Deal art programs followed that precedent. The New Deal project with the widest reputation was the WPA/FAP (Federal Art Project), which was set

CAT. 66

up to put artists to work. To get on the FAP payroll, an artist had to be certified as financially needy by a local relief agency, and prove to officials that he or she had been previously an artist by profession. Most importantly for artists, they were generally free to develop artistically. Traditional limitations such as race and gender were absent. Artists were encouraged to focus on the problems of the times for their subject matter. Realism was the most common mode of expression.

Nearly 5,000 artists were employed in federal programs. The money spent represented less than one percent of the WPA budget, but the funding enabled young artists, some of whom later became famous, to continue to develop their creative skills. There were work standards that needed to be met, such as reporting to a workshop each day. Lithography was the most popular medium, and prints were stamped with a regional WPA stamp.

Sadly, the eventual shutdown of the Federal Art Project was accompanied by terrible treatment of the prints. Many were discarded or used as scrap paper during World War II. Fortunately, many went to museums or were kept by artists or salvaged by government workers. I was privileged to take part in a panel discussion on November 4, 2000, entitled "Who Owns WPA Prints." Sylvan Cole, a pioneer dealer, organized the program for the International Fine Art Dealers Association. The other panelists were artist Will Barnet, a lawyer, a museum director, and an art historian. The general conclusion was that collectors and dealers had helped save many WPA prints. Because artists had been allotted three prints of each image, it would be impossible to determine whether ownership should revert to the government.

Artists in the 1930s had a few other meager sources of support. A fortunate development was the founding of print clubs that grew during the 1920s and '30s, including those in Cleveland and Philadelphia, where members purchased new prints. Additionally, a handful of galleries, such as Weyhe, Associated American Artists, and Kennedy, managed to stay open and were supportive of artists (*The American Scene*, 14–18). Associated American Artists invited well-known artists to create images on lithographic stones. The gallery printed limited editions and sold them inexpensively. American Artists Group, in 1936, began publishing affordable unsigned editions. In 1937, the Ameri-

can Artists Congress held simultaneous exhibitions in thirty cities which included prints made by many of the artists who had been employed by the WPA (Johnson, 69–70).

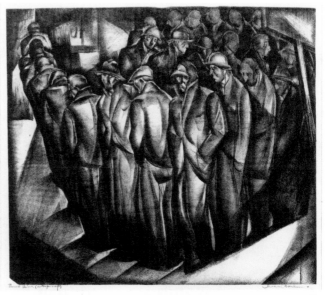

CAT. 67

Whereas before the Depression, artists were drawing landscapes, subways, busy streets, and other "daily life" scenes, the tone of the country changed so dramatically that the natural progression was to "social realism." I define social realism, with respect to prints, as artists' interpretations of troubling events or conditions seen by them, depicting economic hardship or social or racial injustice.

The stock market crash of October 1929 is thought by many to be the tipping point into the Depression. One could argue that the crash was not the cause of the Depression but rather the result of over-speculation. Over the years it has become clear that among the real causes of the ensuing Depression were tight money, trade wars, and mistaken government fiscal policy. Regardless, Bernarda Bryson's *Crash* (cat.

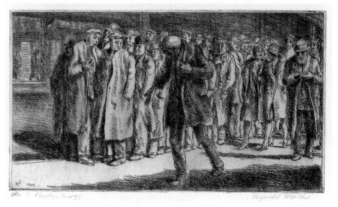

CAT. 68

66) captures the shock to the country of the stock market collapse. The panic-stricken face running through the image is reminiscent of Munch's *Scream*. Bryson was married to Ben Shahn, another prominent artist.

Perhaps the most enduring image of the Great Depression is that of the bread line, dejected people waiting in long lines to get a bite to eat. Different renderings of them are seen in *Bread Line* by Iver Rose (cat. 67), *Breadline* by Reginald Marsh (cat. 68), and *Bread Line, New York* by Claire Leighton (cat. 69). Rose used a cubist style in a lithograph with a line of men in a seemingly endless semi-circle. Marsh, one of the artists best known for picturing scenes of daily life in New York, including burlesque and theater, shows a line of impoverished men. This etching is accentuated by a beggar even more desperate in front of the line. Claire Leighton's wood engraving of the endless line-up is made more powerful by the looming skyscrapers in the background. It is as if the workers of the building boom are now in the never-ending breadline. This print was loaned to the

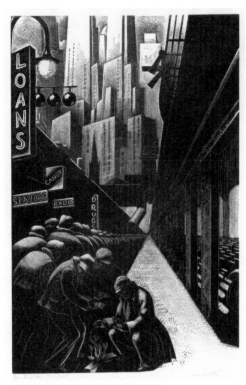

CAT. 69

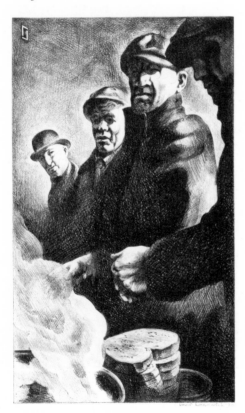

CAT. 70

Whitney Museum of American Art in 1999 for its exhibition of art in America during the first fifty years of the twentieth century.

Lozowick's *Thanksgiving Dinner* (cat. 70), while not a breadline image, captures the empty and seemingly hopeless victims of unemployment, which reached 25% during the 1930s. This was a soup kitchen in the Bowery.

Jacob Burck, one of the leading social activists among artists, drew *The Lord Provides (Work or Bread)* (cat. 71) to illustrate vividly the class conflicts of the mid-thirties. The broad disparities between the haves and have-nots of the 1920s had a strong effect on life in the 1930s.

Don Rico, in his two small wood engravings, *Bootblack, Class of '27* (cat. 72) and *Unemployed* (cat. 73), sums up the egalitarian nature of the Depression. Very few were spared the hardships. Like the prints of Lozowick, Jacobi, Cook, and Lewis, practically every image I have seen of Rico's resonates with me. Print collecting has been about discovering artists of all degrees of fame and living with the pleasure of seeing them on a daily basis.

Land of Plenty by Lucienne Block (cat. 74) was one of the prints chosen for the American Artists' Congress, thirty duplicate exhibits in 1936. It was a juried show; several contemporary artists made their lists of 100 prints, and then the votes were tallied. It was a socially conscious exhibition, trying to make art accessible to the public and stimulate interest in purchasing prints. No commentary about this print was made in the book that illustrated the exhibition itself, (*Graphic Works of the American Thirties*) nor, as far as I can ascertain, in the exhibition itself. However, the dramatic contrast of the

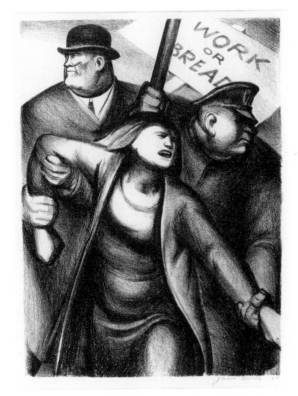

CAT. 71

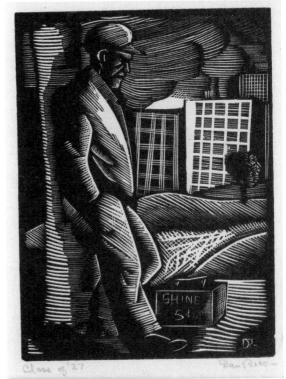

CAT. 72

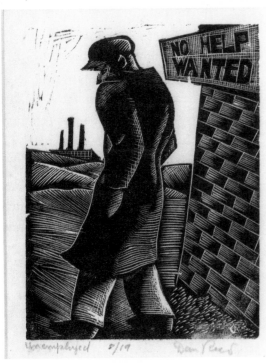

CAT. 73

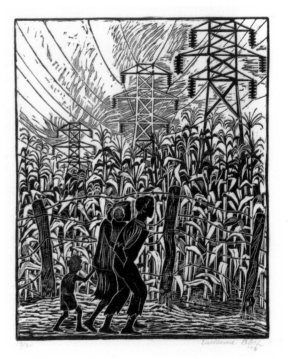

CAT. 74

power lines and abundant cornfields with the silhouette of the downtrodden family needs no prose.

Another image from the 1936 exhibition is Kalman Kubinyi's *Calla Lily* (cat. 6). The stamp of the Federal Art Project attests to his employment by the WPA. As a resident of Cleveland, where the economy was dominated by manufacturing, he was naturally drawn to the factories. This enigmatic print is a perfect emblem for this joint exhibition and catalog. The calla lily's seductive beauty is superimposed over the coal fumes coming from what could be steel plants. Like several other prints on my long-time wish list, it was found by a dealer, in this case by Ed Ogul of Paramour Fine Prints.

Street Scene, Market Street, by Pele de Lappe (cat. 75), has generated quite a bit of discussion as to intent (Seaton, 120–121). She was a long-time member of the Communist Party and a fervent anti-fascist. She was also a member of the John Reed Club, an

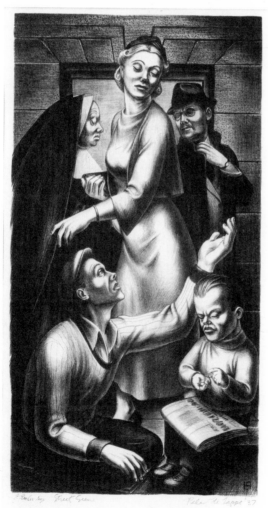

organization of Communist artists and writers. According to de Lappe, several of the figures are drawn from people she would see on Market Street in San Francisco. The assemblage of them seems to indicate a condemnation of the church, of businessmen, and affluent shoppers who fail to help disabled and unemployed Americans. It points to her view of a failed capitalism (Seaton, 120–121). Dijkstra, however, believes the print conveys haunting narrative ambiguities. "In its complexity it is at once a commentary on class, money, and social relationships in America, and a striking example of the intricately layered, and anything but 'simplistic' content characteristic of so much of the art that falsely came to be denigrated and denounced as 'merely propagandistic' during the postwar years" (Dijkstra, 257). I met lively ninety-year old Ms. de Lappe at the Susan Teller Gallery, and when I asked her about this print, she was coyly non-committal about her intent.

CAT. 75

50

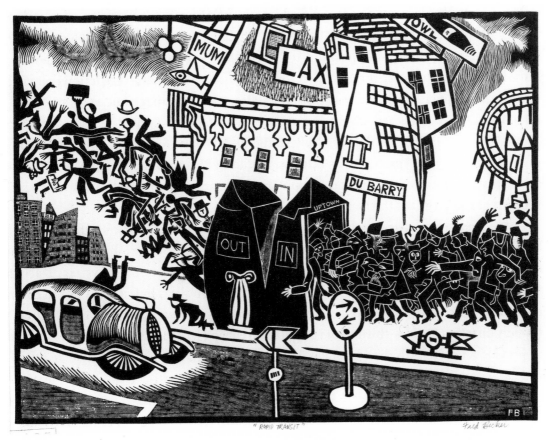

"RAPID TRANSIT" Fred Becker

CAT. 76

Satire

ARTISTS IN THE 1920S AND 1930S often expressed themselves in ways that held their subjects up to ridicule. Satirical prints can exaggerate or parody some behavior in a playful manner or pillory class distinctions or pomposity in a scathing way. Britain had a long tradition of it, and there was plenty of political satire in this country in the nineteenth century.

Thomas Nast was probably the best known satirist to use drawings in the nineteenth century. As a cartoonist for *Harper's Weekly*, he skewered politicians, most famously Boss Tweed, who had gained control of New York City's government and defrauded it of millions of dollars. Nast's cartoons are credited with getting Tweed arrested and convicted.

Richard Masteller, writing in a catalog of an exhibition *"We, The People?" Satiric Prints of the 1930s*, organizes satire into three major categories: social, political, and cultural. Satiric prints in the 1930s had an edge to them. The artists highlighted social foibles, political and financial maneuvering, and they expertly exposed and mocked the perceived deficiencies of American life.

51

The twentieth-century story of satirical images begins with *The Masses*, a magazine of socialist politics published from 1911–1917. The magazine was a leading agitator for labor, women's rights, and opposition to World War I. The controversial decision by President Wilson to enter the War was followed quickly by sharp restrictions on civil liberties. Sweeping legislation was passed dealing with espionage and sedition (Goldman, 196). *The Masses* died after being charged with sedition under the Espionage Act (Zurier, 25–27). It appears that the bulk of the illustrations for *The Masses* were done as drawings and not reproduced as lithographs. John Sloan was among the artists who drew illustrations. Profiteering was a popular subject and anticipated the outpouring of such art at the height of the Depression.

In the Depression decade of the 1930s, the magazine *New Masses* (started in 1926) became a major outlet for a revolutionary Marxist approach to graphic art. Artists intended to present art as grounded in class structures of the capitalist system. During the 1920s, national income was high and unemployment low, but control of the country's industries was steadily concentrating. The national wealth was far from proportionally distributed. One-third of the population earned less than the necessary amount to provide a family with the "decencies" of the period (Goldman, 221–222). The intent of *New Masses* was to create a sense of solidarity with the working class, and to foster a desired "classless" state (Muller, 5–6). Leading artists for *New Masses* included William Gropper and Jacob Burck, whose work is discussed earlier in this catalog, and Hugo Gellert. In contrast to the earlier version of *The Masses*, the art was often intended to be circulated as prints.

Most of these prints speak for themselves. Among the more gentle of the satirical prints is Fred Becker's *Rapid Transit* (cat. 76). It is a humorous view of individuals lost in a crowd. Urban America is being chided for being faceless, with people drifting aimlessly through life.

Burges Green's *Crocodile Tears* (cat. 77) mocks the indifference of too many comfortable people to the economic and social deprivation all around.

Jack Markow's *Grand Hotel* (cat. 78) subtly contrasts a street drifter staying warm on a subway with an advertisement for a "grand" hotel.

Abe Blashko, in *The Pillars* (cat. 79), has a field day with bloated rich people flaunting their self-appointed superiority, including a huge dangling cigar and oversized fur coat.

Alexander Stavenitz's *Street Scene - New York, 1932* (cat. 80) is very simple in its composition. A poor skinny chap selling apples is passed by an oversized couple, indifferent to his poverty.

Peggy Bacon's *Pleading for the Oppressed* (cat. 81) is a wonderful commentary on many politicians. While the poor guy is making his case, the ones who should care are yawning, reading or doing anything but caring. Bacon was one of the leading artists

of the 1930s. She was a prolific printmaker, painter, writer, illustrator, and poet. Her work tended to be imbued with wit and humor (Seaton, 88–89). I first saw this print at a museum exhibition put together by David Kiehl. I knew Peggy Bacon had been represented by Kraushaar Gallery. Tucked away in their inventory was this scarce print.

Elizabeth Olds's two prints in this exhibition are more serious. She believed that American artists should use the Depression as a subject just as Mexican artists used their history and background in their murals. Between 1935 and 1940, she was employed by the WPA Federal Art Project New York in the Graphics Division. Her print *The Middle Class* (cat. 82) won first prize at the 1939 Philadelphia Art Alliance print annual.

The Middle Class must be examined closely to see the horrible array of things in it. Reading about Elizabeth Olds's views of economic injustice leads me to believe that in this print she is imploring the "middle class" of the country to stop turning a blind eye to the rich businessmen, who are looting them, and to the Ku Klux Klan, which is taking aim at them. They should stop trying to wall themselves off from the attempts of labor to achieve a larger share. The "middle class," or bourgeouisie, should shake off the suppression of the forces that were fencing them in, and join forces with the proletariat. Olds was among the most radical of the left-wing artists, submitting many drawings to *New Masses* magazine, attacking capitalists.

1939 A.D. (cat. 83) draws on FDR's inaugural address of 1933, which attacked the

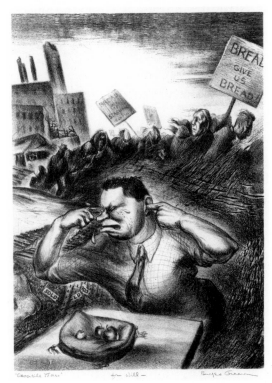

CAT. 77

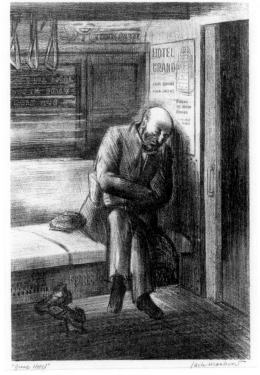

CAT. 78

53

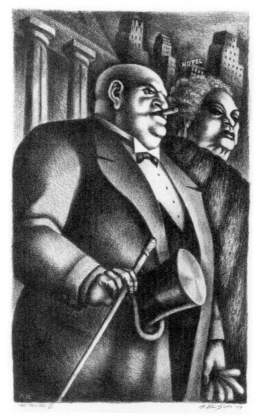

CAT. 79

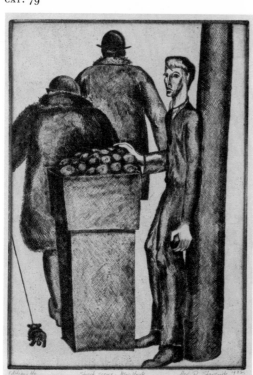

CAT. 80

"money changers": "Plenty is at our doorstep, but a generous use of it languishes in the very sight of the supply. Primarily this is because the rules of the exchange of mankind's goods have failed through their own stubbornness and their own incompetence, have admitted their failures and abdicated. Practices of unscrupulous money changers stand indicted in the court of public opinion, rejected by the hearts and minds of men. . . . The money changers have fled their high seats in the temple of our civilization. We may now restore the temple to the ancient truths. The measure of that restoration lies in the extent to which we apply social values more noble than mere monetary profit." (www. Americanrhetoric.com/speeches/fdrfirstinaugural. html, March 25, 2011)

Olds used the capitalists of Wall Street as the surrogates, as they flee from the advancing rank and file, led by a Christ-like figure. The Stock Exchange, the "temple" of capitalists, is getting purified. In this print every social program of that decade is lined up against big business.

Sometimes, the more one looks at an image, the more one sees and understands. In Mabel Dwight's *Merchants of Death* (cat. 84), the eye is, of course, drawn to her portrayal of grotesque capitalists being led by a grim reaper skeleton, as they coldly calculate their ploys. They morph into vultures as the viewer's eye passes from left to right. The smokestacks add an ominous note. Closer inspection shows what appear to be just shadows, but are instead fingers pointing to the men as if to add to their guilt and shame. "Merchants of Death" was the term

used by some in the 1930s to vilify manufacturers of armaments who were accused of unduly influencing America to enter World War I.

Ernest Crichlow was one of the prominent African-American printmakers of the 1930s and '40s. He studied at the Art Students League and New York University, and worked at the Federal Art Project in Greensboro, North Carolina. His *Lovers* (cat. 85) is

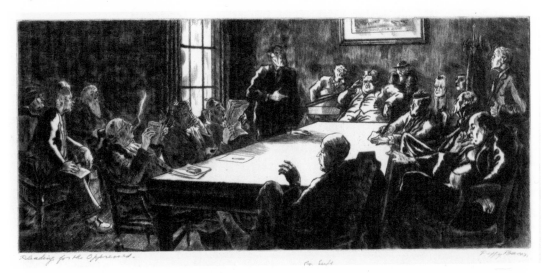

CAT. 81

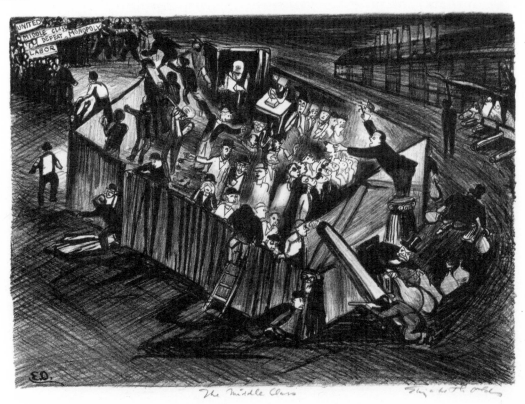

CAT. 82

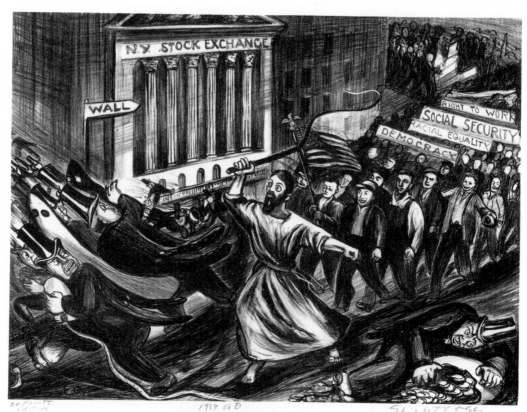

CAT. 83

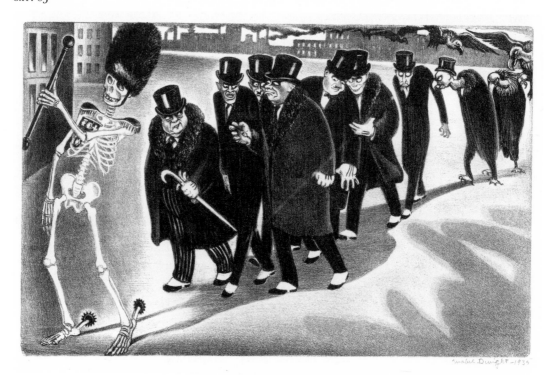

CAT. 84

a harrowing skewering of the Ku Klux Klan. The ugliness of the segregationists was portrayed in many lynching scenes as well. This image, however, leaves the viewer to imagine the aftermath of their crime.

Raymond Steth was another important African-American printmaker. *I am an American* (cat. 86), like so many political prints, needs no explanation. He produced a powerful series of studies that reflect critically on the African-American experience in this country. His prints demonstrate the freedom black artists had under the WPA to express their take on the American Scene (King-Hammond, 6–9). While the government did little to further civil rights of African-Americans, it did

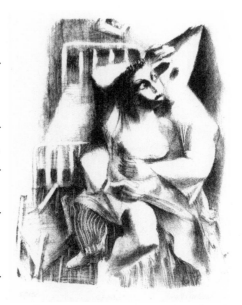

CAT. 85

offer equal opportunity in the WPA. As a result, a strong visual legacy remains as a reminder of the issues facing black America.

Albert Potter worked in linocuts, which, like Eli Jacobi's Bowery images, do a sparkling

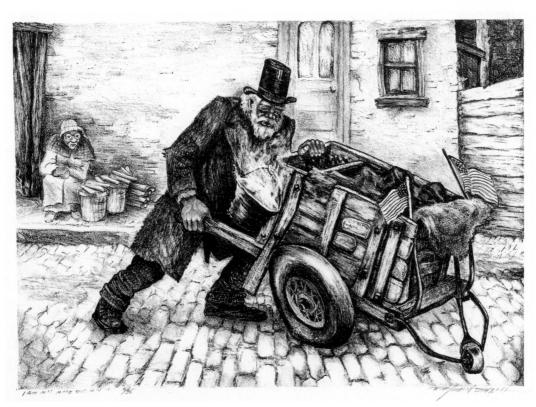

CAT. 86

job of conveying a feel for the Depression. *Brother Can You Spare a Dime* (cat. 87), was the name of a hit song recorded both by Rudy Vallee and Bing Crosby. Both versions reached number one in the charts. It became, in essence, the anthem of the Depression. It spoke of past great achievements, "now done, Brother can you spare a dime?" In addition to the dominant figure looking for assistance, there are fragments of skyscrapers, bridges, Broadway, and on top of it all, a cracked skull. After seeing a copy of this print at the Museum of the City of New York, I called Susan Teller, from whom I had previously purchased a Potter print of the Lower East Side. As luck would have it, she had just obtained one of the few copies of *Brother* from a Potter family member.

Finally, Hugo Gellert's *Primary Accumulation #14* (cat. 88) is typical of his lithographs, as is *Machinery and Large Scale Industry* (cat. 89). As a group, Gellert's prints are the most powerful and anti-capitalist satirical images from that period, and maybe of any period. He also lobbied for interracial solidarity in his prints.

Gellert was born in Hungary but grew up in the United States. A family visit to Hungary exposed him to the horrors of World War I. His cousin died from gangrene in the Carpathian Mountains. His younger brother, a draft resister, was murdered while imprisoned at Fort Dix. As noted earlier with respect to *The Masses* magazine, political dissent was considered unpatriotic by many, especially during World War I.

Gellert had trained as an artist and had designed movie and theater posters. He won cash prizes for his artwork, and motivated by his distaste for the war, submitted drawings to *The Masses*. His anti-war drawings led to his subsequent co-founding of *The New Masses*. Despite his views on war, during World War II Gellert served as chairman of Artists for Victory. His posters for the war effort were highly praised.

CAT. 87

CAT. 88

Through his art and his political activism as a member of the Communist Party, he fought against fascism and for economic justice as he saw it. During the Depression he wrote and illustrated two books of sharp satire, *Comrade Gulliver* and *Aesop Said So*. The lithographic illustrations were issued as a separate portfolio. *Karl Marx Capital in Pictures* was issued as a portfolio as well, and in the context of the day, was enormously powerful, and, of course, controversial. Regardless of one's political sympathies, one cannot help but be greatly moved by his lithographs.

Regarding the acceptance of Communism by many artists and intellectuals of the 1930s, it should be noted that such views may seem more understandable because of the anti-Hitler, anti-fascist feelings. Russia had seemed to advance under its five-year plans, and many progressives felt that the national planning of the Roosevelt administration was an implied endorsement. The flirtation with communism by "fellow travelers," those who were sympathizers with communism but not actual party members, dissipated with the signing of the Nazi-Soviet Non-Aggression Pact of 1939 (Goldman, 274–280).

In 1939, writing about the prints chosen for the World's Fair, John Taylor Arms and Hugo Gellert said they believed that the American art form, while lacking in some of the uniformly high degree of technical excellence of contemporary English prints or old masters, possessed a spontaneous expression of national spirit, a directness and individuality of approach, and a frank and uncompromising portrayal of national life unsurpassed in any other country (*American Art Today*, 242–244). It is my hope that those sentiments are reflected in this collection.

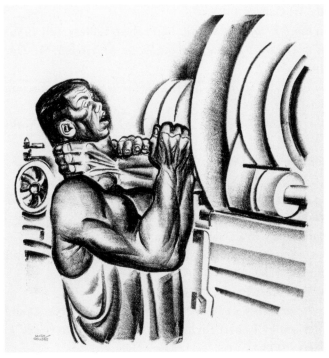

CAT.89

Bibliography

Adams, Clinton. *American Lithographers 1900–1960: The Artists and their Printers*. Albuquerque, NM: University of New Mexico Press, 1983.

After the Crash. Washington, DC: Smithsonian Institution, National Collection of Fine Arts, October 24, 1979–January 13, 1980.

Allen, Frederick Lewis. *Since Yesterday: The 1930s in America*. New York: Harper & Row, 1939.

American Art Today: New York World's Fair. Poughkeepsie, NY: Apollo Publishing, 1987. Reproduction of the 1939 catalog.

American Master Prints from the Betty and Douglas Duffy Collection. Washington, DC: The Trust for Museum Exhibitions, 1987.

American Prints 1900–1950. New Haven: Yale University Press, 1983.

The American Scene: Prints from Hopper to Pollock. London: The British Museum Press, 2008.

Beall, Karen F. *American Prints in the Library of Congress: A Catalog of the Collection*. Baltimore and London: Johns Hopkins Press, 1970.

Bryant, Edward. *Pennell's New York Etchings, 90 Prints*. New York: Dover Publications, 1980.

A Century and a Half of American Art 1825–1975. New York: National Academy of Design, 1975.

Craven, Thomas, ed. *A Treasury of American Prints*. New York: Simon & Schuster, 1939.

Czestochowsky, Joseph S. *Gerald K. Geerlings*. Cedar Rapids: Cedar Rapids Art Association, 1984.

Dijkstra, Bram. *American Expressionism: Art and Social Change 1920–1950*. New York: Harry N. Abrams in association with the Columbus Museum of Art, 2003.

Dreppard, Carl W. *Early American Prints*. New York: The Century Co., 1930.

Duffy, Betty and Douglas. *The Graphic Work of Howard Cook: A Catalogue Raisonné*. Bethesda, MD: The Bethesda Art Gallery, 1984.

Eli Jacobi: Linoleum Block Prints. New York: Mary Ryan Gallery, July 1986.

The Federal Art Project: American Prints from the 1930s. Ann Arbor, MI: University of Michigan Museum of Art, 1985.

Fleurov, Ellen. *No Sun without Shadow: The Art of Harry Sternberg*. Escondido: Museum, California Center for the Arts, 2000.

Flint, Janet. *The Prints of Louis Lozowick: A Catalogue Raisonné*. New York: Hudson Hill Press, 1982.

Goldman, Eric. *Rendezvous with Destiny*. New York: Alfred A. Knopf, 1956.

Goodrich, Lloyd. *Edward Hopper*. New York: Harry N. Abrams Inc., 1976.

Graphic Works of the American Thirties: A Book of 100 Prints: An Unabridged Reproduction of the 1936 Publication. New York: Da Capo Press, 1977.

Hugo Gellert. New York: Mary Ryan Gallery, 1986.

The Image of Urban Optimism. Organized by Jane M. Farmer for the Smithsonian Institution Traveling Exhibition Service, 1977.

James E. Allen. New York: Mary Ryan Gallery, 1984.

Johnson, Una E. *American Prints and Printmakers*. Garden City, NY: Doubleday & Co., 1980.

Jones, Dan Burne. Revised by Robert Rightmire. *The Prints of Rockwell Kent*. San Francisco: Alan Wofsy Fine Arts, 2003.

King-Hammond, Leslie. *Black Printmakers and the W.P.A.*: Bronx, NY: The Lehman College Art Gallery, The City University of New York, February 23–June 6, 1989.

Kraeft, June and Norman. *Great American Prints, 1900–1950*. New York: Dover Publications Inc., 1984.

_____. *Armin Landeck: The Catalog Raisonné of his Prints*. Carbondale, IL: Southern Illinois University Press, 1994. 2nd ed.

McCarron, Paul. *The Prints of Martin Lewis, A Catalog Raisonne*. Bronxville, NY: M. Hausberg, 1995.

Masteller, Richard N. *"We, The People?" Satiric Prints in the 1930s*. Walla Walla, WA: The Donald H. Sheehan Gallery, Whitman College, 1989.

Minutes: Society of Iconophiles of New York 1895–1909. From the Library of the Grolier Club.

Morison, Samuel Eliot and Henry Steele Commager. *The Growth of the American Republic*. New York: Oxford University Press, 1960. Vol. 2.

Muller, Mary Lee. *Imagery of Dissent: Protest Art from the 1930s and 1960s*. Madison, WI: University of Wisconsin-Madison, Elvejen Museum of Art, March 4–April 1989.

The New York Etching Club Minutes, November 12, 1877, through December 8, 1893. Illustrated and annotated by Stephen A. Fredericks. Houston: Rice University Press, 2009.

Pele de Lappe. Exhibition Oct.–Nov. 2000. New York: Susan Teller Gallery, 2000.

Pennell, Joseph. "The Pictorial Possibilities of Work," *Journal of the Royal Society of Arts* 61, (1912–13).

Reese, Albert. *American Prize Prints of the 20th Century*. New York: American Artists Group, 1949.

Ryan, Mary. "Brother Can You Spare a Dime: Printmakers, the Great Depression, and the WPA." *Visions of a Changing America: Depression Era Prints from the Collection of Herschel and Fern Cohen*. Huntington, NY: Heckscher Museum of Art, February 7–April 19, 1998.

Saville, Jennifer. *John Taylor Arms: Plates of Perfect Beauty*. Honolulu: Honolulu Academy of Arts, 1995.

Seaton, Elizabeth G. *Paths to the Press: Printmaking and American Women Artists 1910–1960*. Manhattan, KS: The Marianne Kistler Beach Museum of Art, Kansas State University, 2006.

Soyer, Raphael. *Self-Revealment: A Memoir*. New York: Maecenus Press-Random House, 1967.

Stauffer, David McNeeley. *American Engravers on Copper and Steel*. New York: The Grolier Club, 1907.

Wagner, Ann Prentice. *1934 A New Deal for Artists*. Washington, DC: Smithsonian American Art Museum, 2009.

Watrous, James. *A Century of American Printmaking 1880–1890*. Madison, WI: University of Wisconsin Press, 1984.

Wechsler, James. *Arthur Murphy*. New York: Mary Ryan Gallery, 1993.

Weitenkamp, Frank. "An Etcher of New York: C. F. W. Mielatz." *The Print Collector's Quarterly* 24, No. 3 (October 1937).

Zigrosser, Carl. *The Artist in America*. New York: Alfred A. Knopf, 1942.

Zurier, Rebecca. *Art for the Masses: A Radical Magazine and its Graphics, 1911–1917*. Philadelphia: Temple University Press, 1988.

1. Harry Sternberg

 Forest of Flame, 1939
 Lithograph
 12 ¼ x 16 ½ in.

2. Howard Norton Cook

 Times Square Sector, 1930
 Etching
 12 x 10 in.
 Edition 7/75

3. James E. Allen

 Teeming Ingots, 1935
 Etching
 11 ⅞ x 9 ⅞ in.

4. Gerald Kenneth Geerlings

 Jewelled City, 1931
 Etching and aquatint
 15 ½ x 11 ⅝ in.

5. Caroline Wogan Durieux

 Bourbon Street, New Orleans, 1943
 Lithograph
 10 ⁹/₁₆ x 9 ⅞ in.

6. Kalman Kubinyi

 Calla Lily, c. 1935
 Aquatint
 9 ½ x 7 ⅜ in.
 Edition c. 25
 Federal Art Project No. 1

7. Charles M. Mielatz

 In the Bowery, 1891
 Etching
 10 x 7 in.

8. Charles M. Mielatz

 Wall Street, New York City, 1892

Etching
12 ¹¹/₁₆ x 9 ½ in.

9. Charles M. Mielatz

 High Bridge on the Harlem River, 1917
 Etching
 12 ½ x 9 ⅜ in.

10. Joseph Pennell

 The Stock Exchange, 1904
 Etching
 11 ¾ x 7 ½ in.

11. Joseph Pennell

 Flatiron Building, 1904
 Etching
 10 x 7 ½ in.
 Edition of 25

12. John Taylor Arms

 West Forty-Second Street, Night, 1922
 Etching and aquatint
 10 ⅝ x 6 ¾ in.
 Edition of 100

13. John Taylor Arms

 The Gates of the City, 1922
 Etching and aquatint
 8 ½ x 8 in.

14. Rudolph Ruzicka

 [Brooklyn Bridge], 1915
 Wood engraving
 7 x 7 in.
 Edition 24/35

15. Lynd Kendall Ward

 Under the El, 1937
 Etching
 5 x 3 ⅜ in.

16. Grace Albee

Contrasts-Rockefeller Center, 1934
Wood engraving
7 ⅛ x 5 ½ in.
Edition 9/100

17. James Swann

Night in Chicago, 1940
Etching
6 ¹³/₁₆ x 10 ¹³/₁₆ in.

18. Walter Tittle

Grand Central Night, c. 1930
Etching
12 ¾ x 8 in.

19. Walter Tittle

Manhattan Minaret, c. 1932
Etching
14 ½ x 9 in.

20. Howard Norton Cook

West Side, New York, 1931
Etching/aquatint
6 ¾ x 12 ⅛ in.
Edition of 50

21. Howard Norton Cook

The New Yorker, 1930
Woodcut
17 ⅝ x 8 ⅝ in.
Edition of 50

22. William McNulty

Towers in the Sun, 1934
Etching
10 ⅞ x 12 ¾ in.
Edition of 100

23. Samuel L. Margolies

Man's Canyons, 1936
Etching and aquatint
11 ¼ x 8 ¾ in.

24. Armin Landeck

Manhattan Canyon, 1934
Etching (drypoint)
13 ¾ x 6 ¾ in.

25. Arnold Ronnebeck

Wall Street, before 1925
Lithograph
12 ½ x 6 ¾ in.

26. Edward Hopper

Night Shadows, 1921
Etching
6 ⅞ x 8 ¼ in.

27. Armin Landeck

Pop's Tavern, 1934
Drypoint and aquatint
6 ⅛ x 10 in.
Edition of 50

28. Anton Schutz

The Great White Way, 1928
Aquatint
13 ⅞ x 9 ⅞ in.

29. James E. Allen

*Untitled [Planes over the Statue of
Liberty],* 1941
Lithograph
11 ½ x 13 ¼ in.

30. John Sloan

Night Windows, 1912
Etching
5 ⅜ x 6 ¾ in.
Edition of 110

31. George Bellows

Preliminaries, 1916
Lithograph
15 ¾ x 19 ½ in.

32. George Overbury (Pop) Hart

Working People, 1925
Etching
6 ½ x 9 ½ in.

33. Levon West

Rainy Day, 1933
Etching and Drypoint
14 ⅜ x 8 ¾ in.
Edition of 12

34. Asa Cheffetz

Monday (The American Scene), 1932
Wood engraving
7 x 10 in.
Edition 10/75

35. Martin Lewis

Quarter of Nine, Saturday's Children, 1929
Etching
12 ¾ x 9 ¾ in.

36. Martin Lewis

Day's End, 1937
Drypoint
9 ⅝ x 13 ⅜ in.
Edition of 34

37. Don Freeman

Automat Aristocrat, 1934
Lithograph
7 x 8 ¼ in.
Edition 41/50

38. Ida York Abelman

Wonders of Our Time, 1937
Lithograph
11 ¾ x 15 ⅛ in.
Edition of 50

39. Isac Friedlander

3 A.M, 1933

Etching
9 ¼ x 15 ⅛ in.

40. William E. Smith

Poverty and Fatigue, 1938
Wood engraving
9 x 7 ⅞ in.
Edition 2/21

41. Grant Wood

In the Spring, 1939
Lithograph
9 x 11 ⅞ in.
Edition of 250

42. Friedolin Kessler

Hey Look, c. 1936
Wood Engraving
7 ⅝ x 10 ¾ in.

43. Fritz Eichenberg

City Lights, 1934
Wood engraving
6 ⅛ x 4 ¾ in.
Edition of 200

44. Eli Jacobi

Chatham Square 'L', 1932
Linocut
9 ¾ x 7 ⅞ in.

45. Eli Jacobi

Mills Alley, 1936
Woodcut
8 x 9 ⅞ in.

46. Eli Jacobi

East of the Bowery, 1939
Linocut
8 x 10 in.

47. Raphael Soyer

The Mission, 1933

Etching
12 x 17 ½ in.

48. Donato [Don] Rico

Home Relief Bureau, c. 1937
Lithograph
16 ⅜ x 13 ⅜ in.
Federal Art Project NYC WPA

49. Maxine Seelbinder

Housing Needed, 1933
Lithograph
12 x 10 ½ in.
Edition 2/7

50. George E. C. Wiggins

Prohibition, 1930
Lithograph
9 x 12 in.
Edition 5/15

51. Kyra Markham

Lockout, 1938
Lithograph
10 x 12 in.

52. Walter LeRoy Flint

Strike Breakers, 1936
Etching
6 x 7 ¾ in.

53. Thomas Hart Benton

Strike, 1933
Lithograph
9 ¹³/₁₆ x 10 ⅞ in.
Edition of 300

54. Louis Lozowick

Strike Scene, 1935
Lithograph
10 ¾ x 8 ⅞ in.
Edition of 10

55. William Gropper

Sweat Shop, 1934
Lithograph
9 ½ x 12 in.

56. James Downey Egleson

The Factory, 1939
Lithograph
11 ½ x 14 ½ in.

57. Harry Sternberg

Drilling in a Breast, 1936
Lithograph
15 ⅛ x 21 ⅜ in.
Edition of 25 or less

58. Michael John Gallagher

Scranton Coal Miners, 1938
Etching and carborundum
7 ⅛ x 14 ½ in.

59. Riva Helfond

Miner and Wife, 1937
Lithograph
11 ¹¹/₁₆ x 8 ¹/₁₆ in.
Edition of 15

60. Charles Turzak

Man with Drill, 1935
Wood engraving
12 x 9 ¼ in.

61. Samuel L. Margolies

Men of Steel, c. 1938–1939
Etching
14 ⅝ x 11 ⁹/₁₆ in.

62. James E. Allen

The Skyman, 1932
Drypoint
12 ½ x 8 ¹³/₁₆ in.
Edition of 100

63. Arthur George Murphy

 Steel Riggers, No. 4, Bay Bridge Series, 1936
 Lithograph
 15 ¼ x 11 ¾ in.

64. Letterio Calapai

 Labor in a Diesel Plant, 1940
 Wood engraving
 15 ⅝ x 9 ½ in.
 Edition 24/50

65. Rockwell Kent

 Big Inch, 1941
 Lithograph
 8 ¹⁵/₁₆ x 12 ⅜ in.

66. Bernarda Bryson

 Crash, 1932
 Lithograph
 10 ⅛ x 8 ⅛ in.

67. Iver Rose

 Bread Line, 1935
 Lithograph
 15 x 17 ¼ in.
 Artist's Proof

68. Reginald Marsh

 Breadline, 1929
 Etching
 4 ⅞ x 8 ⅞ in.
 Edition 8/50

69. Clare Leighton

 Bread Line, New York, 1932
 Wood engraving
 12 x 8 in.
 Edition 8/100

70. Louis Lozowick

 Thanksgiving Dinner, 1938
 Lithograph
 12 ½ x 7 ½ in.

71. Jacob Burck

 The Lord Provides (Work or Bread), 1934
 Lithograph
 11 ⅞ x 8 ⅞ in.
 Edition of less than 100

72. Donato [Don] Rico

 Bootblack, Class of '27, 1934
 Wood engraving
 4 ¹/₁₆ x 3 ⅛ in.
 Proof before the edition in *The Masses*

73. Donato [Don] Rico

 Unemployed, 1934
 Wood engraving
 4 ¹/₁₆ x 3 ⅛ in.
 Edition 8/19

74. Lucienne Bloch

 Land of Plenty, 1935
 Linocut
 10 ½ x 8 ¾ in.
 Edition 12/30

75. [Phyllis] Pele de Lappe

 Street Scene, 1937
 Lithograph
 16 ¼ x 8 ⅞ in.

76. Fred Becker

 Rapid Transit, c. 1939
 Woodcut / Federal Art Project NYC WPA
 10 ½ x 13 ¾ in.

77. Burges Green

 Crocodile Tears, c. 1935
 Lithograph
 15 x 10 ¾ in.

78. Jack Markow

 Grand Hotel, c. 1938
 Lithograph
 13 ½ x 9 ¼ in.

79. Abe Blashko

> *The Pillars*, 1939
> Lithograph
> 18 ¾ x 12 in.
> Edition 10/35

80. Alexander Raoul Stavenitz

> *Street Scene – New York*, 1932
> Etching
> 10 ½ x 7 ½ in.
> Edition of 40

81. Peggy Bacon

> *Pleading for the Oppressed*, 1936
> Drypoint
> 6 ⅞ x 15 ⅞ in.

82. Elizabeth Olds

> *The Middle Class*, c. 1938
> Lithograph
> 9 ⅞ x 14 in.

83. Elizabeth Olds

> *1939 A.D.*, 1939
> Lithograph
> 11 ½ x 15 ¾ in.
> Edition of 20

84. Mabel Dwight

> *Merchants of Death*, 1935
> Lithograph
> 8 x 12 ⅞ in.

85. Ernest Crichlow

> *Lovers*, 1938
> Lithograph
> 14 x 9 ½ in.
> Edition 23/30

86. Raymond Steth

> *I am an American*
> Lithograph
> 7 ¾ x 11 ¼ in.
> Edition 4/35

87. Albert Potter

> *Brother Can You Spare a Dime*, c. 1932
> Linocut
> 13 x 8 in.

88. Hugo Gellert

> *Primary Accumulation # 14*, 1933
> Lithograph
> 14 x 13 in.

89. Hugo Gellert

> *Machinery and Large Scale Industry*
> From *Karl Marx Capital in Pictures*,
> 1933
> Lithograph
> 14 x 13 in.
> Portfolio 19/133

ACKNOWLEDGEMENTS

We owe a debt of gratitude to many people at the Grolier Club, which we have found to be so welcoming to us and where we are thrilled to be members.

This catalogue and exhibition would never have been possible had we not fortuitously met Lisa Baskin, who introduced us to the Grolier Club and shepherded us through the membership process. Her understanding of our collecting passions has led to our being part of a wonderful group, where every member shares our enthusiasm.

Anne Hoy and Szilvia Szmuk-Tanenbaum were the driving forces behind the idea of a joint exhibition of our collections and were so helpful with advice about its content, as well as in presenting it to the Committees on Members' Exhibitions and Prints, Drawings, and Photographs. Anne has a major knack for coming up with fascinating titles. We think "Steel and Roses" encompasses our two different collections perfectly.

Fernando Peña, the Grolier Club librarian, has given so generously of his time and shared the Club's marvelous resources. Eric Holzenberg, the Club Director, has been supportive at every step. We also want to thank Maev Brennan for her work with us.

We can't think of enough superlatives to describe the editing talents and dedication of George Ong. His patience and knowledge are outstanding. His constructive suggestions for changes to wording, his ability to catch misplaced commas and periods, as well as more importantly, inconsistencies, after we thought we had been so careful, is nothing short of amazing.

Megan Smith has been a terrific guide in the planning and execution of the exhibition and we are thankful of the expertise of her volunteer committee hanging the exhibition.

Finally, Jerry Kelly, who designed this as well as so many wonderful catalogues, allayed our anxieties about form, layout, and timing at our first meeting. We are thrilled with his creativity and expertise. We are so fortunate to have had all these talented people to guide us.

TYPESET IN MILLER AND BULMER TYPES · DESIGNED BY JERRY KELLY

INDEX OF AUTHORS AND ARTISTS

Numbers refer to catalogue numbers

Moulton, Gary E.. ed. *Herbarium of the Lewis and Clark Expedition: The Journals of the Lewis and Clark Expedition*, Volume 12. Lincoln, NE and London: University of Nebraska Press, 1999.

Pauly, Philip J. *Fruits and Plains: The Horticultural Transformation of America*. Cambridge: Harvard University Press, 2007.

Plants in Print: The Age of Botanic Discovery. Chicago Botanic Garden, in collaboration with the United States Botanic Garden. Exhibition September 18–November 7, 2004.

Raphael, Sandra. *An Oak Spring Pomona: A Selection of the Rare Books on Fruit in the Oak Spring Garden Library*. Upperville, VA: Oak Spring Garden Library, 1990.

Reese, William S. *Stamped with a National Character: Nineteenth Century American Color Plate Books, An Exhibition*. New York: The Grolier Club, 1999.

Regis, Pamela. *Describing Early America: Bartram, Jefferson, Crevecoeur, and the Rhetoric of Natural History*. DeKalb, IL: Northern Illinois University Press, 1992.

Reveal, James L. *Gentle Conquest: The Botanical Discovery of North America with Illustrations from the Library of Congress*. Washington, DC: Starwood Publishing, Inc., 1992.

Rix, Martyn. *The Art of the Plant World: The Great Botanical Illustrators and their Work*. Woodstock, NY: The Overlook Press, 1980.

Rodgers, Andrew Denny III. *American Botany 1873–1892: Decades of Transition*. Princeton: Princeton University Press; London: Humphrey Milford, Oxford University Press, 1944.

Saunders, Gil. *Picturing Plants. An Analytical History of Botanical Illustration*. Second edition. Chicago and London: KWS Publishers in association with The Victoria and Albert Museum, 2009.

Stevenson, Allan, comp. *Catalogue of Botanical Books in the Collection of Rachel McMasters Hunt*. Pittsburgh: The Hunt Botanical Library, 1961. 3 vols.

Three Centuries of Botany in North America: An Exhibit Celebrating the Publication of "Wildflowers of the United States". New York: The Rockefeller University Press, 1967.

Tomasi, Lucia Tongiorgi. *An Oak Spring Flora, Flower Illustration from the Fifteenth Century to the Present Time: A Selection of the Rare Books, Manuscripts and Works of Art in the Collection of Rachel Lambert Mellon*. Upperville, VA: Oak Spring Garden Library, 1997.

Wolschke-Bulmahn, Joachim and Jack Becker. *American Garden Literature in the Dumbarton Oaks Collection (1785–1900): From The New England Farmer to Italian Gardens. An Annotated Bibliography*. Washington, DC: Dumbarton Oaks Research Library and Collection, 1998.

Wulf, Andrea. *The Brother Gardeners: Botany, Empire, and the Birth of an Obsession*. New York: Alfred A. Knopf, 2009.

_____. *Founding Gardeners: The Revolutionary Generation, Nature, and the Shaping of the American Nation*. New York: Alfred A. Knopf, 2011.

BIBLIOGRAPHY

❦

Bennett, William. *A Practical Guide to American Nineteenth Century Color Plate Books.* New York: Bennett Book Studios, 1949. Reprinted by the Hayden Foundation for the Cultural Arts, Inc., Ardsley, New York, 1980.

Bridson, Gavin D. R. and Donald Wendel. *Printmaking in the Service of Botany. 21 April to 31 July, 1986. Catalogue of an Exhibition.* Pittsburgh: Hunt Institute for Botanical Documentation, Carnegie-Mellon University, 1986.

Blunt, Wilfred and William T. Stearn. *The Art of Botanical Illustration.* London: Collins, 1950.

Desmond, Ray. *Great Natural History Books and their Creators.* London: The British Library and New Castle, DE: Oak Knoll Press, 2003.

Dunthorne, Gordon. *Flower and Fruit Prints of the 18th and Early 19th Centuries: Their history, makers and uses, with a catalog raisonné of the works in which they are found.* Washington, DC: Published by the author, 1938.

Ewan, Joseph, ed. *A Short History of Botany in the United States.* New York and London: Hafner Publishing Company, 1969.

Groce, George C. and David H. Wallace. *The New York Historical Society's Dictionary of Artists in America, 1564–1860.* New Haven and London: Yale University Press, 1957.

Harshberger, John W. *The Botanists of Philadelphia.* Mansfield Centre, CT: Martino Publishing, 1999. A facsimile of the 1899 edition published by T. C. Davis & Sons.

Hedrick, U. P. *A History of Horticulture in America to 1860.* New York: Oxford University Press, 1950.

Henrey, Blanche. *British Botanical and Horticultural Literature before 1800: Comprising a history and bibliography of botanical and horticultural books printed in England, Scotland, and Ireland from the earliest times until 1800.* Oxford: Oxford University Press, 1975. 3 vols.

Johnston, Stanley H., comp. *The Cleveland Herbal, Botanical, and Horticultural Collections: A Descriptive Bibliography of Pre-1830 Works from the Libraries of the Holden Arboretum, the Cleveland Medical Library Association, and the Garden Center of Cleveland.* Kent, OH and London England: The Kent State University Press, 1992.

Keeler, Nancy. *Gardens in Perpetual Bloom: Botanical Illustration in Europe and America 1600–1850.* Boston: Museum of Fine Arts, 2009.

Kramer, Jack. *Women of Flowers: A Tribute to Victorian Women Illustrators.* New York: Stewart, Tabori & Chang, 1996.

MacPhail, Ian. *The Sterling Morton Bibliographies in Botany and Horticulture: Benjamin Smith Barton and William Paul Crillon Barton.* Lisle, IL: The Morton Arboretum, 1986.

_____. *The Sterling Morton Bibliographies in Botany and Horticulture: André and François-André Michaux.* Lisle, IL: The Morton Arboretum, 1981.

accomplished artist and the plates here are similar to ones she used to illustrate her series of adult books, they are uncolored and appear to be by another artist.

48. [ANONYMOUS]

The Alphabet of Flowers. London: Dean and Son, [n.d., but c. 1855].

This sentimental alphabet of flowers is unusual in that it has delicately hand-colored plates on a black background. The cover of this thin paper pamphlet shows a "tussy-mussy," a popular Victorian gift of a bunch of flowers gathered together in a lacey doily, with two insects attesting to how fresh the flowers are.

49. [ANONYMOUS]

The Alphabet of Flowers for Good Children. With Illustrations Engraved by Edmund Evans. London: Routledge, Warnes, and Routledge, [n.d., but c. 1860].

This is one type of "alphabet of flowers" books that was popular during the mid-and late-nineteenth century flower mania. Each flower is illustrated with an engraving and a sentimental two-line rhyme. Horticultural shows were important for spreading the word about the best varieties of plants. Adults and children attended.

Rr stands for ROSE, old England's flower,
Prized-one of palace, of cottage, and bower;
It scents the free air, wherever it grows:
Other flowers smell sweet, but none like the Rose.

CAT. 48

Z is for ZINIA, which carries away
The prize at the Grand Show of Flowers to-day.

CAT. 49

CAT. 46

The author explains that many children attended horticultural meetings with their mothers (this period of time being "the age of flowers" in England and France) and wanted to know more about what they were seeing. She discusses both the Linnaean system of classification and the Jussieu Natural System, concluding that the Linnaean is the one to study as a first introduction.

The plates in this little book were drawn and engraved by J. D. Sowerby (1787–1871), naturalist, artist, and eldest son of James Sowerby, famous for the plates in *The Botanical Magazine* (cat. 29) and *English Botany*. Early children's gardening books maintained the high quality of illustration common in English and European books in general. This was part of the "Little Library "series, which included two volumes of *The Garden* (1833), a horticulture book for children.

This copy has a presentation inscription on the flyleaf "Mary & Sarah Fox from their Governess. 6 Month. 1835."

CAT. 47

47. MRS. [JANE WEBB] LOUDON (1807–1858)

My Own Garden; or The Young Gardener's Yearbook. London: Kerby & Son, 1855.

Jane Webb Loudon learned horticulture from her husband, the celebrated landscape gardener and horticultural writer, John Claudius Loudon, and collaborated on his works. After his death she wrote her own series of practical garden books (see cat. 27), mainly for women.

In this children's book, she lays out the principles of how to choose a site, what tools are needed, how to plant seeds, bulbs, and roses, and how to transplant, water, prune and train, all according to the four seasons. Her advice is straightforward and easy to follow, but doesn't talk down to her audience. Although she was an

Children's Gardening Books

SINCE ADMIRING AND GROWING flowers was considered an appropriate activity for women in the nineteenth century, it is understandable that they would want to develop in their children an appreciation of gardens, as well as knowledge about gardening. Books about gardening for children began to appear. Most are small in size to fit into the child's hands. Some are sentimental, using poetry to describe flowers; some are scientific, trying to make botany easy for a child to understand. Others are storybooks with the theme of gardening and flowers. And some are alphabets of flowers. Most are illustrated.

The collection includes a number of children's gardening books of all the above descriptions ranging from the early nineteenth century into the early twentieth century in England, France, and America. The selections in this exhibition are all nineteenth century English or French works and are either botanicals or alphabets.

CAT. 45

45. [ANONYMOUS]

Botanique de La Jeunesse: Avec Trente Planches Contenani Les Principes de la Botanique et Cent deux Plants. Paris: Chez Delaunay, Libraire, 1812.

This anonymously written and illustrated manual for children explains the botanical systems of Linnaeus and Jussieu in simple language. It features detailed black and white engravings as well as beautiful and delicate hand-colored engraved plates with four flowers on each. This copy is from the famous Arpad Plesch collection of botanical books, with his leather bookplate.

46. CAROLINE A. HALSTED

The Little Botanist: or Steps to the Attainment of Botanical Knowledge. London: John Harris, 1835. 2 vols.

This introduction to botany is taught·by the author through a series of conversations with a little girl, which she intended as a model to be copied by parents with their own children. The back and forth between Mama and Louisa is charming, and enables the reader to picture the environs in which it is taking place and the caring and warm relationship between an earnest little girl and her mother, who is interested in instructing her.

CAT. 44

44. MRS. C. M. [Clarissa Munger] BADGER (1806–1889)

Wild Flowers Drawn and Colored from Nature. New York and London:
Charles Scribner and Sampson Low, Son & Co., 1859.

Although not a typical language of flowers book, in that it doesn't explain the hidden meanings
of flowers, this is an example of a work by a creative woman in a style appropriate for women's
work in the Victorian period. Each of twenty-one species of plants is illustrated by a hand-colored lithograph and is accompanied by a poem about that plant.

Clarissa Munger, married to the Reverend Milton Badger, was an artist of plants and flowers.
In the list of flowers that precedes the illustrations, she includes the Class and Order of each
plant as well as the blooming dates.

the botanical description of each plant and the description of the environs where the plant was found. The innovative plates featured hand-colored flowers against a black-and-white backdrop of the location where they grew. They were lithographed by Lewis and Brown of New York, whose imprint is on the frontispiece, and were hand-colored by Whitefield.

It is interesting to note how the background of the wild columbine plate from the book differs from the proof plate also shown here. The proof has the locale of the plant handwritten in pencil: "Matanga Fall near Wyalusing, PA". Henry T. Tuckerman, the author of the sonnet about the sentiment, inconstancy, is known for his 1867 biographical history of American artists, *The Book of the Artists*.

43. MRS. E. W. [Elizabeth Washington] WIRT (1784–1857)

Flora's Dictionary. Baltimore: Lucas Brothers, 1855.

CAT. 43

Flora's Dictionary is a prime example of the "language of flowers" books so popular in the nineteenth century. The book went through many editions, of which this is a later one, having been first handwritten for her family and friends and eventually published with hand-colored lithographs in 1837. Each flower, alphabetically listed, is associated with its sentiment, accompanied by poetry to illustrate the hidden meanings of the flowers.

The author, Elizabeth Washington Gamble, was married to William Wirt, and raised twelve children in Virginia, Washington, and Baltimore. As was typical for the period, her name is given as Mrs. E. W. Wirt, and on the title page is added "of Virginia." What is unusual for this sentimental book is the amount of botanical information about the structure of plants and flowers and how they are classified, including a detailed biography of Linnaeus, with the pages decorated with intricate borders.

Appended is an alphabetical list of sentiments and the flowers that represent them, so presumably the owner of this book could use it to analyze what the flowers she is given are supposed to be telling her.

The beautiful illustrations were engraved in color by Victor, who had a printing workshop in Paris, after paintings by the renowned French artist, Pancrace Bessa (1772–c. 1835). Bessa had studied with Redouté and Redouté's teacher, Spaendonck, and provided engravings for Redouté's *Les Roses*. Wilfred Blunt, in his classic *The Art of Botanical Illustration*, praised Bessa's work but believed "... he frittered away too much of his time and energy upon small sentimental flower books which did not give his great talent full scope" (Blunt, 181).

CAT. 42

CAT. 42

42. EMMA C. EMBURY (1806–1863)

American Wild Flowers in their Native Haunts. New York: D. Appleton & Company, 1845.

This is a work of writings by Emma Embury, as well as poems by her and others, loosely structured around plates and descriptions of flowers. Some of the writings had been anonymously published earlier, as was the case with many women's writings in the mid-nineteenth century. Each flower pictured is assigned a sentiment, such as sympathy, hopelessness, jealousy, innocence, answered love, and the poem and story relate to that theme.

The plants were collected and drawn by Edwin Whitefield (1816–1892), a landscape and flower painter in England, who came to America in about 1840. He was also responsible for

Sentimental Books

In the Victorian age, "the gentle Englishwoman was treated more as a delicate flower to be adored but not touched, and certainly not tainted by working at a profession" (Kramer, 58). In the eighteenth and nineteenth centuries, there were creative, talented women who were botanical artists and writers. However, their work was usually done to help their husbands or fathers or, if it was their own pursuit, it was done anonymously. Even when known, they were often listed as Miss or Mrs. and their work was often disparaged by critics.

In both Europe and America, women were encouraged to grow flowers, take up drawing, and study botany as healthful and innocent pursuits. The Romantic Age emphasized nature, and flowers were everywhere, in decorations in the home and on women's clothing. Even modest houses had gardens.

Flowers became symbolic of biblical morality, love, and classical virtues. Characteristics of flowers, such as clinging vines or upright statures, often indicated their symbol. Women's creative endeavors led to poetry and writing about these characteristics. A genre of botanical literature, "language of flowers" books, was developed mostly by women to express themselves about the moral implications of flowers. They became extremely popular and were often given as gifts to women by their admirers.

41. CHARLOTTE DE LATOUR [Louise Cortambert]

Le Langage des Fleurs, par Madame Charlotte de Latour. Paris: Audot, [n.d.]

This little gift book, so wildly popular in France, was copied and imitated all over Europe. The author, Louise Cortambert, wife of a famous geographer at the Bibliothèque Nationale, wrote under a pseudonym, as was common for women authors in the early nineteenth century.

She speaks to young ladies who were studying plants, either to make perfumes or paint them, and explains that the type of flower and the way it was held or drawn would affect the meaning. Going through the seasons, she explains how each flower expresses a feeling relating to the season, e.g., in the summer, beauty, amiableness, voluptuousness; in winter, consolation, melancholy, motherly love.

CAT. 41

lineate Linnaeus's system and thoroughly explain each of the parts of a flower, are accompanied by lavishly produced engraved charts, title pages, and portraits, the most famous of which is of Linnaeus in Lapland dress. The third part is actually "The Temple of Flora," floral plates with descriptions and writings.

To produce the plates that Thornton envisaged required a large number of artists, both painters and engravers, and Thornton closely supervised every stage of the process, including choosing the plants for the paintings and deciding on the backgrounds for them. This being the "Romantic" period, backgrounds were dramatic, often dark and exotic, appealing to Gothic novel readers of the time (Desmond, 117). The engravers used several processes (aquatint, mezzotint, stipple and line engraving), then the plates were color printed, and additional color was added by hand. It was a very expensive labor-intensive project.

The parts began to be issued, in no particular order, in 1799, and continued until 1807, when Thornton had to abandon the project because he had depleted his wealth. Twenty-six of the projected seventy plates were issued. Although the intention was to organize them according to Linnaeus's classes and orders, the plates and accompanying text were not placed in an organized fashion and no two copies of this work are exactly the same.

The rose plate (cover) is the only one in *The Temple of Flora* that was painted by Thornton himself; the engraver, Earlhom, used mezzotint and line engraving. The text that follows the plate is typical for all of the text in this section. Following a description of the botanical characteristics are many poems, both by classical and contemporary authors. The plate entitled "The Nodding Renealmia" is done with stipple and line engraving and aquatint.

40. JEAN-JACQUES ROUSSEAU (1712–1778)

La Botanique de J. J. Rousseau, Ornée de soixante-cinq planches, imprimées en couleurs, d'après les peintures de P. J. Redouté. Paris: Baudouin Frères, 1821.

Jean-Jacques Rousseau, the philosopher and writer, is known for his belief in the natural man. He was introduced to botany in 1762 when a friend in Switzerland showed him Linnaeus's new system of naming plants. He began "botanizing," i.e., collecting plants and organizing them. In the 1770s, he wrote a series of letters to a French woman, Madame De Lessert, who wanted to teach her daughter about the science. They were published as *Lettres Elementaires sur la Botanique*. In 1805, Rousseau's ideas experienced a resurgence of interest, and the letters were published with sixty-five plates stipple-engraved after paintings by Redouté.

This edition of 1821 is the second large quarto issue. The plates of flowers, fruits, and plant parts are the attraction and are situated first, followed by the *Lettres* and an addendum of *Fragments Pour un Dictionnaire des Termes de Usage en Botanique,* a botanical dictionary that Rousseau never completed.

CAT. 39

CAT. 39

AMYGDALUS PERSICA. PÊCHER COMMUN EN FRUIT.

CAT. 40

RACINES.

CAT. 40

CAT. 38

CAT. 38

The plates for Redouté's *Les Liliacées*, are elegant artistic creations but also botanically accurate and painted from live specimens. Besides members of the lily family, they also include amaryllis, iris, and orchid families. This monumental work eventually ran to eight volumes over a period of fourteen years (1802–1816), and employed eighteen artists to engrave the 486 plates and several botanists to write the text (Keeler, 88).

39. ROBERT JOHN THORNTON (c. 1768–1837)

New Illustration of the Sexual System of Carolus Von Linnaeus: *Comprehending an elucidation of the several parts of fructification; A prize dissertation on the sexes of plants; A full explanation of the classes, and orders, of the sexual system; and the Temple of Flora, or garden of nature, being picturesque, botanical, coloured plates of select plants, illustrative of the same, with descriptions.* London: Printed for the Publisher by T. Bensley, 1807.

The Temple of Flora is only part of the title of this celebrated monumental work, but it's the name that it's known by because of the dramatic flower prints it contains. Robert Thornton became obsessed with the idea of combining the "Science of Botany" and the "Arts of Painting and Engraving" with a tribute to Linnaeus. Thornton was a doctor and eccentric who devoted his life and fortune to the publishing of this work. Even the first two sections of text, which de-

(1708–1770), as well as fifty-seven pages of text in Latin describing the botanical classification system of Linnaeus. Trew, a physician and botanist in Nuremberg, became a patron to many botanical artists, "the intellectual counterpart of London's Hans Sloane" (Keeler, 14).

Ehret was born in Heidelberg, worked briefly as a gardener while practicing drawing that he had been taught by his father, and, while employed as a botanical artist in Regensburg, made many drawings of plants that were seen by Trew, who encouraged him "to study plants from a scientific as well as an artistic perspective" (Tomasi, 187). From 1733–1736, Ehret traveled through Europe and England, where he met the foremost botanists, plant collectors, and gardeners of the time. He was particularly influenced by Linnaeus, and his learning of Linnaeus's classification system informed the way he depicted plants. He engraved a table of Linnaeus's system that was widely used in publications, notably the 1737 edition of Linnaeus's *Genera plantarum*. All the time he was traveling he was sending Trew large folio-sized drawings of plants he had seen, many of them at the Chelsea Physic Garden in London. After he settled in London, he had several important patrons, worked on drawings for many publications, made paintings on vellum, and became a teacher of flower painting.

The extraordinary plates, produced over a period of about twenty years, were all engraved and hand-colored by J. J. and J. E Haid, considered among the best engravers in Nuremberg (Keeler, 49), from original drawings by Ehret. His page-filling designs are, at the same time, scientific and visually exciting. "With his unerring sense of form and colour, elegant style and unusual mastery of technique, Ehret managed to create a unique and quite personal vision, so accurate and realistic that each painting became an almost idealized version of the actual subject" (Tomasi, 190).

38. PIERRE-JOSEPH REDOUTÉ (1759–1840)

Les Liliacées. Paris: De L'Imprimerie de Didot Jeune, 1802. Vol. I.

Pierre-Joseph Redouté was the most famous and popular botanical artist in history. His exquisite paintings for three of his major works, *Jardin de la Malmaison, Les Liliacées,* and *Les Roses,* were a record of the flowers grown at Malmaison, the chateau of Josephine Bonaparte, who, in 1798, became his protector. In addition he provided paintings and engravings for many other works of his own and others, and claims to have invented, but at least certainly popularized, the technique of stipple engraving. This technique, used to such wonderful effect here, is etching with dots instead of lines, which enables the artists to produce a gradation of tones. A single plate is used for color printing and the color is applied à la poupée, or with a rag.

Born in Belgium into a family in which all three sons became artists, Pierre-Joseph traveled throughout Europe, studied Flemish masters and arrived in Paris to work at the Jardin du Roi. He was tutored in the scientific basis of botanical painting by a wealthy botanist, L'Héritier de Brutelle, collaborated with him on his books, and studied with the Dutch flower painter Gerard van Spaendonck. Under the latter's teaching, Redouté mastered watercolor and developed a style in which the individuality of each flower was depicted with delicacy and detail. "Royal patronage, tireless energy, and the assistance of a brilliant team of stipple engravers and printers, made it possible for him to produce illustrated books which have few rivals in the whole history of botanical art" (Blunt, 179).

Florilegia

FLORILEGIA ARE FLOWER BOOKS in which the plates are much more important than the text (Saunders, 41). In fact, some florilegia have no text at all. They are traditionally representations of collections of flowers, often in the gardens of wealthy patrons. This type of book became particularly popular in the seventeenth century, as more exotic plants were being brought into English, Dutch, French, and German gardens through exploration and as a garden for pleasure began to be as important as a garden for medicinal use.

I categorize the grouping of eighteenth and nineteenth century works shown here as florilegia because the exquisite artwork of the plates are the attraction. They could fit equally well into the category of Botany since they were executed by artists who were well trained in that science and have texts that explain Linnaeus's system. Rousseau's work includes his letters about botany for the instruction of his correspondent's daughter. However, the main reason for the acclaim of these books are the plates engraved by the best engravers of the period after paintings by the finest botanical artists in history.

CAT. 37 CAT. 37

37. CHRISTOPH JAKOB TREW (1695–1769)

Plantae Selectae. [Nuremberg: N.p.], 1750–1773.

This magnificent work, conceived of and published by Christoph Trew, consists of 100 hand-colored engraved plates by the eighteenth century's greatest botanical artist, Georg Dionysius Ehret

plants, and besides writing two books on native plants, being a plant explorer and active in state and national organizations, he edited *The Gardener's Monthly and Horticultural Advertiser* for thirty years (1859–1889).

The journal follows the pattern of other American journals, with domestic and foreign correspondence, reports on horticultural societies, answers to questions and tasks for each month in the flower, fruit, and vegetable garden, adding the greenhouse now that more gardeners could afford them. The articles are illustrated with line engravings as well as a few frontispieces in color lithography. The *Advertiser* section of the monthly journal gives us a look into gardening at the beginning of the Civil War period in America. The ads are all for companies north of Maryland, but as far west as Iowa.

36. C. M. [CHARLES MASON] HOVEY (1810–1887)

The Magazine of Horticulture, Botany, and all Useful Discoveries and Improvements in Rural Affairs. Boston: Hovey & Co., 1866. Vol. XXXII (Vol. II, Fifth series).

This horticultural magazine began life in Boston in 1835 as *The American Gardener's Magazine, and Register of Useful Arts*, but in 1837 changed to this title, still edited by Charles Mason Hovey, and continued until 1868. About the time of the founding of this journal, Hovey became well known as the breeder of the first excellent strawberry in America, and later went on to write *The Fruits of America* (cat. 17), which is cited on the title page of this issue from 1866.

As might be expected, each month featured several articles on fruit growing. The section titled "Horticultural Operations," giving advice to gardeners as to what tasks they should be accomplishing, is divided into fruit, flower, and vegetable. The journal has few illustrations and no adornment to the pages.

It was much more a home-grown journal, with fewer references to foreign publications than earlier journals. However, the influence of British gardeners and writers is obvious in the obituary notice in the January issue, which records the passing of Sir Joseph Paxton, Sir W. J. Hooker, and Professor Lindley, with the note that "It will be difficult to supply the places which these distinguished men filled" (p. 11).

The first article of this issue deals with the effects of the Civil War. "The year opened with the continuance of the dread rebellion, but it has closed upon a free nation, within whose boundaries every man can claim the reward of his labor" (p. 1). It goes on to show the patriotic and optimistic feeling after the end of the war as it related to horticulture: "... labor, now that it belongs to none other than he who performs it, will be more zealously devoted to the improvement of the soil, and with intelligent industry will spring up a taste for trees and plants, which will make many of the heretofore waste places 'blossom like the rose'" (p. 1).

34. A. J. [ANDREW JACKSON] DOWNING (ed.) (1815–1852)

The Horticulturalist and Journal of Rural Art and Rural Taste: Devoted *to horticulture, landscape gardening, rural architecture, botany, pomology, entomology, rural economy, &c.* Albany: Luther Tucker, 1846–47. Vol. I.

Already well known by the age of twenty-six for his influential book, *A Treatise on the Theory and Practice of Landscape Gardening*, Downing published two other important books, *Cottage Residences* and *The Fruits and Fruit Trees of* America (cat. 16), before starting this journal. The influence of his interests and writings can be seen in the choice of topics and the illustrations. Many of the articles are about fruit culture as well as landscape gardening. Opposite the title page of most issues is a black and white plate of a country home and often a floor plan.

Each issue begins with an essay by Downing, who writes in a comfortable, friendly style as if talking directly to his readers. Well-known American growers contributed articles on plants, most often fruit trees, but also roses and other flowers. "Foreign Notices," a monthly section, contains short items selected from journals, catalogues, and books and "Domestic Notices" also includes letters from readers about horticultural topics. Most issues also report activities of the various horticultural societies.

The issue for January 1847 begins with an article about the Duke of Devonshire's country residence, Chatsworth, which Downing has visited and about which he gives his impressions. He recognizes that the grand scale of such dwellings will not be able to be maintained past the nineteenth century. The Duke of Devonshire "is, as you very well know, quite at the head of the people who are *garden-mad*" (p. 300). His Grand Conservatory covered an acre of land, was seventy feet high, and could be driven through with a coach and four. Fifty thousand rhododendron, planted by the great gardener for the Duke, Joseph Paxton, were growing in an arboretum, which he defined for his readers and described as "the leading fashion in England" (p. 301).

35. THOMAS MEEHAN (ed.) (1826–1901)

The Gardener's Monthly and Horticultural Advertiser. Philadelphia: Published at 23 North Sixth Street, 1860. Vol. II.

Thomas Meehan was, at a young age, a gardener and botanist in England before emigrating to America. In 1853 he established his own nursery in Philadelphia that became known for native

CAT. 35

Cattleya crispa

CAT. 33

33. JOSEPH PAXTON (1803–1865)

Paxton's Magazine of Botany and Register of Flowering Plants. London: W. E. Orr & Co., 1838. Vol. 5.

Sir Joseph Paxton, of humble origin, rose to become the chief gardener and manager of the Duke of Devonshire's great estate, Chatsworth House. A. J. Downing writes with awe about his visit there in an 1846 issue of his journal, *The Horticulturalist* (cat. 34). Paxton's talents as an engineer and architect led him to design garden structures, the largest and most famous of which was the Crystal Palace in Hyde Park, site of the Great Exhibition of 1851, which ultimately burned down.

Paxton's *Magazine of Botany* (1834–49) was contemporaneous with the beginnings of American journals. Each monthly issue was illustrated with four plates, mostly hand-colored lithographs, but many plates were also aquatints, engravings and etchings. American journals of this time generally had few, if any, colored illustrations. In the *Magazine of Botany* there were also many woodcut illustrations in the text, especially in the earlier volumes, showing garden plans, greenhouses, and tools. Just as garden tasks for each month were featured in American journals, so too did Paxton include them, but his were divided among the flower garden, greenhouses, and stoves (hot houses), aiming at his more sophisticated and wealthier audience.

Orchids were becoming very popular among the British gardening public, as exotic plants were the rage and greenhouses to house them were not uncommon. Paxton's magazine often featured information on orchids, as well as articles on new species, culture, potting, and hot houses for them.

CAT. 31

CAT. 32

cieties, floriculture near Boston, extracts from foreign publications, and garden work for that month. The eclectic mix of topics included the cultivation of the asparagus, use of the knife in horticulture, grapes and the manufacture of wine, forcing the cherry, flowers for the pleasure garden, color of plants and flowers, cultivation of the dahlia, horticultural architecture, the study of botany, and electricity and conductors. Frequent references to the British publications, Loudon's *Gardener's Magazine*, Curtis's *Botanical Magazine* (cat. 29) and works of John Lindley and William Paxton (cat. 33) show how influential British horticultural writing was to American garden writers.

Five of the monthly issues (February, March, April, July, and September) of this first volume of the journal feature an in-depth study of a plant accompanied by a beautiful black and white lithograph. This was not repeated in the remainder of the journal, which continued to publish until 1838, having been taken over by nurseryman Joseph Breck, who acquired it as part of a purchase of other properties. He was one of the first members of the Massachusetts Horticultural Society, later became its president (Hedrick, 251), and was later also a frequent contributor to Downing's journal (cat. 34).

cal Magazine (cat. 29), although each of the ninety plants featured in this volume has more scientific information. Edwards also has a nine-page list of the books cited as references for the plants and indicates at which nursery or plant collector's garden the drawing for each of the plants was made. Many British botanical journals included dramatic fold-out plates such as the one shown here.

31. HORTICULTURAL SOCIETY OF LONDON

Transactions of the Horticultural Society of London. London: W. Bulmer & Co., 1818. Volume II.

The Horticultural Society of London was chartered in 1809 "for the improvement of Horticulture in all its branches, *ornamental* as well as *useful*" (Preliminary Observations, ii). From both the Preface and the Preliminary Observations in this volume, it seems that those favoring the ornamental (flowers) and those favoring the useful (fruits and vegetables) were not always in agreement. ". . . [A]lthough the Society may often be impelled to give a seeming preference to the useful branches of Horticulture before the ornamental, still it should be fully known that the Pleasure Garden possesses both physical and moral advantages, which are capable of benefiting the lowest as well as the highest classes of Society, and therefore unavoidably claims the protection and encouragement of this Corporate Body" (ibid.). The Horticultural Society promoted practical gardening and therefore did not "enter the precincts of Botany" (Preface, iv).

In this second volume of *Transactions*, selected from papers given from 1812 through 1817, the useful seems to win. Most of the presentations and illustrations are of fruit, vegetables, or black and white engraved plans for growing houses. The emphasis on the useful is very much in line with American horticulture at this time, but preference for the useful lasted much longer in America. The page shown here, *An Account of a new Peach from North America*, with a beautiful color plate, shows how interested British horticulturalists were in American plants, which led the Horticultural Society to send explorers on plant hunting trips to America.

32. THOMAS G. FESSENDEN (1771–1835) and J. E. TESCHENMACHER (eds.)

Horticultural Register and Gardener's Magazine. Boston: George C. Barrett, 1835.

Garden journals published in America before the 1830s, such as the *New England Farmer* (1822–1846), were primarily agricultural but gave space to horticulture as well. Thomas G. Fessenden was its editor and responsible for the emphasis on gardening and for encouraging through his journal the founding of the Massachusetts Horticultural Society. He was an author of note and, near the end of his life, edited the first two volumes of *Horticultural Register and Gardener's Magazine,* devoted to "practical husbandry, gardening, and the sciences intimately connected with rural pursuits" (Hedrick, 495).

Each monthly issue featured regular sections devoted to information about horticultural so-

mediate success, and early volumes such as this one were quickly reissued (this is a 1790 printing of the 1787 first volume, followed by the 1788 second volume). After Curtis died in 1799, *The Botanical Magazine* continued under a succession of other authors until 1984 when it was merged into another periodical, which continues to this day.

Each monthly issue of *The Botanical Magazine* included three hand-colored copper engravings of the highest quality. Some of the most important botanical artists of the day, many of whom had worked on Curtis's *Flora Londinensis* (cat. 8), drew and engraved the plates, including, in this volume, James Sowerby and Sydenham Edwards (cat. 30), both of whom later went on to found their own periodicals. By 1845, lithography replaced engraving, but the plates were still hand-colored until 1948, and the quality never diminished (Keeler, 72).

CAT. 29

30. SYDENHAM TEAST EDWARDS (1769?–1819)

The Botanical Register, Consisting of coloured figures of exotic plants cultivated in British gardens; with their history and mode of treatment. London: James Ridgeway, 1815. Vol. 1.

Sydenham Edwards was brought to London from Wales when just a boy to be instructed by William Curtis, who was looking for talented artists to work on his *Flora Londinensis* (cat. 8). In addition to plates for that work, Edwards engraved 1600 of the 1721 plates for the first twenty-eight years of the *Botanical Magazine* (Keeler, 72). However, in 1815, a misunderstanding caused him to leave the magazine and start this rival, which was published from 1815–1847 (Blunt, 192).

Edwards's *Botanical Register* looks very much like *The Botani-*

CAT. 30

Botanical Journals

BOTANICAL BOOKS were often published in parts and bound together by the owner after all the parts were accumulated. In Europe, production of these books was often financially underwritten by subscribers and/or patrons. They were generally aristocrats, wealthy landowners, botanists, and plant collectors, but the books were not intended for the average person.

Botanical journals broadened the audience for botanical books to enthusiasts of botany or horticulture who wanted practical information about how to grow exotic plants, as well as descriptive information. In England and Europe, illustration was an important addition to description. Editors employed pre-eminent botanical artists and engravers to work on their publications. Each monthly number usually consisted of text and one or more plates. The quality, quantity, and beauty of the color plates in English journals form a stark contrast to American journals, which are extremely informative and comprehensive, but have no claim on beauty.

The practical nature of American life ensured that early botanical journals would be devoted to agriculture, especially fruit growing, rather than flower gardening. Journals also began later than in England and did not have the stable of artists producing illustrations. In fact, most journals have few, if any, illustrations and those they do have are usually lithographs, since that printing technique began to be developed in America at about the same time as the appearance of journals.

The proliferation of botanical journals aimed at the general public on both sides of the Atlantic in the nineteenth century is an indication of the growing popularity of the science and art of cultivating a garden.

29. WILLIAM CURTIS (1746–1799)

The Botanical Magazine; or The Flower Garden Displayed. : IN WHICH *the most ornamental foreign plants, cultivated in the open ground, the green-house, and the stove, are accurately represented in their natural colors,* TO WHICH ARE ADDED, *their names, class, order, generic and specific characters, according to the celebrated Linnaeus; their places of growth, and times of flowering:* TOGETHER WITH THE MOST APPROVED METHODS OF CULTURE. *A work intended for the use of such ladies, gentlemen, and gardeners, as wish to become scientifically acquainted with the plants they cultivate.* London: William Curtis, 1787 (repr. 1790) and 1788.

This volume of the famous botanical periodical, usually referred to as *Curtis's Botanical Magazine*, includes Volumes I and II, which were issued in parts and bound together by the subscriber. It was designed to appeal to a wide audience of gardeners obsessed with their exotic plants from distant lands and was to combine botany and horticulture. *The Botanical Magazine* was an im-

28. ROBERT WARNER (1815–1896) and
BENJAMIN SAMUEL WILLIAMS (1824–1890)

The Orchid Album, Comprising coloured figures and descriptions of new, rare, and beautiful orchidaceous plants. London: B. S. Williams, 1882–1897. 11 vols.

CAT. 28

Orchids were among the most showy and exotic plants that were introduced to England by botanical explorers and were desired by garden enthusiasts. Robert Warner was an orchid grower with a large clientele. He and Benjamin Samuel Williams had each written an orchid book when they began this monthly publication, which eventually ran to 132 parts and 528 chromolithographs (*Plants in Print,* 34). Their goal was to provide botanical and cultural information for all of the many species and varieties of orchids and to depict and describe them accurately. The royal quarto format allowed enough room for dramatic illustration of these beautiful plants, and chromolithography had advanced sufficiently to be able to produce very high quality plates. The plates are both color lithographed and hand-colored.

The explanation that precedes the description and culture of each plant was provided by Thomas Moore, long-time curator of the Chelsea Botanic Gardens, and all of the colored figures were done by John Nugent Fitch, nephew of Walter Hood Fitch, both artists who had worked on *The Botanical Magazine* (cat. 29). *The Orchid Album* "set the standard for orchid description and illustration" (ibid., 23).

27. MRS. [JANE WEBB] LOUDON (1807–1858)

The Ladies Flower-Garden of Ornamental Greenhouse Plants. London: William Smith, 1848.

CAT. 27

Jane Webb Loudon was already a writer when she met her much older husband, John Claudius Loudon (1783–1843), a major landscape gardener and horticultural writer. Under his guidance, she learned gardening and became his researcher and collaborator on his *Encyclopedia of Gardening,* published in 1834. She realized that she could help other women learn gardening and wrote *Instructions in Gardening for Ladies* (1840) to explain gardening in a simple style that she thought would appeal to women like her. It did and went through nine editions (Kramer, 123). She became a prolific garden writer on her own, especially after her husband died severely in debt.

This book was what started me in my botanical book collecting, and fit perfectly because I was a gardener building a greenhouse at the time. It was also a good book with which to start a collection because it gave me more titles to pursue and establish a list of desiderata. *The Ladies Flower-Garden* was a series of four titles, *Annuals, Perennials, Bulbous Plants* and *Greenhouse Plants,* published between the years 1840 and 1848. Another book, *British Wild Flowers*, was published following the same format in 1846.

The format of *Flower-Garden* was simple and appropriate for its audience. With brief text, Loudon gives simple botanic characteristics of each plant, followed by a description written in a chatty style that tells where it was found and how to grow it. The forty-two plates show several species within the genus, arranged like a bouquet; the plate here illustrates Fuchsia, named after the celebrated botanist Leonard Fuchs, author of the landmark botanical work, *De Historia Stirpium* (1542). The plates are lithographs, which had just begun to replace engravings in the 1840s and are hand-colored.

In this book Loudon focused on exotic plants that were not hardy in England and, she explains, were generally more beautiful but harder to grow than those covered in her earlier books. Because of botanic exploration there was an influx of new species of plants from Asia, Australia, South America and South Africa that English women were seeing and wanted to grow. She explains that "my works are intended solely for amateurs" (Introduction, B); therefore, she is not including "stove" plants, which would need a gardener to be grown well. There is a difference between greenhouses, which are kept relatively cool (between 45°F and 60°F), and stoves, which are kept above 60°F, where one could grow tropical plants.

36

His celebrated *Gardener's Dictionary*, first published in 1731, was so successful that it went through eight editions in his lifetime. Sold by subscription, it was also bought by all levels of society. Peter Kalm, who was sent by Linnaeus to collect plants in America, wrote that the best horticulturalists in England and America believed it to be "the best of all, and that when one has it, no other book is afterwards required" (Henrey, II:217). George Washington always had it open on his study table and consulted it when designing tree and shrub plantings at Mount Vernon (Wulf, *Founding Gardeners*, 23) and it was among the horticulture books Thomas Jefferson relied on for names of plants. (ibid., 64). "*The Dictionary* and its success reflected the emerging spirit of the time, and in particular of the Enlightenment, in which the traditions of the ancients were replaced by a rational approach to knowledge and nature" (Wulf, *Brother Gardeners*, 46).

Miller's *Dictionary* was a new type of book, an encyclopedic manual on gardening. Besides being a catalogue of all the plants growing in England, it explained in detail how to care for and propagate them. It was written in straightforward English. His advice was based on the

voluminous notes he wrote down each night of his work at the Chelsea Physic Garden, and his successes and failures in growing plants (ibid., 39). All of the information is arranged alphabetically, and in the first edition, Miller includes all the names that other authors had given to each plant. However, coming after the publication of Linnaeus great work in 1753, this seventh edition of The *Gardener's Dictionary* "adopted the phrase-names of the Species Plantarum whenever applicable"(Henrey, II:652). Most works after this used Linnaeus's system of binominal nomenclature.

Most of the plates in *The Gardener's Dictionary*, which illustrate some plants but more structures for growing them, were drawn and engraved by John Miller, who is represented by another work of his own in this exhibition (cat. 2). However, the plate shown here is by Georg Dionysius Ehret, the acclaimed botanical artist (see cat. 37), who, when he moved from Holland to England, married Miller's sister-in-law.

CAT. 26

CAT. 25

nist and actor before returning to employment as an apothecary, and beginning a successful and energetic career as a writer. His botanical writing alone was prodigious, but he also wrote criticism that made him widely hated. Even in this work on gardening, one gets the feeling that this man is very self-centered, spending a great deal of the preface criticizing others' writings and promoting his own. Blanche Henrey surmises that the publisher did not want this unpopular person's name on the publication (Henrey, II:99), which may be why his name does not appear on the title page of *Eden* although it is commonly referred to as *Hill's Eden*.

This work is truly a "complete body of gardening." Week by week, it provides descriptions and growing information for plants that flower in that period, as well as Linnaeus's classification and very clear explanations of why they are classified as such. Hill also advises what general gardening tasks are to be done during each part of the year, and explains the techniques of laying out flower, vegetable, and fruit gardens. The hand-colored plates show several stems of flowers on each. Most of the flowers were drawn from nature by Hill and engraved by him; some were copied from the early seventeenth-century work, *Hortus floridus* by Crispian de Passe, and other plates, such as the ones shown here, were drawn and engraved by others. It was common practice to appropriate plates and even text from earlier botanical works; in fact, plates and text were copied from Hill's *Eden* later in the century (ibid., 98).

26. PHILIP MILLER (1691–1771)

The Gardener's Dictionary: Containing the best and newest methods of cultivating and improving the kitchen, fruit, flower garden, and nursery, as also for performing the practical parts of agriculture. London: Printed for the author; sold by Charles Rivington, 1759. Seventh edition; 2 vols. in one.

Philip Miller was highly educated and trained by his family to become a nurseryman. He was passionate about gardening and, in his forty-eight years as gardener at the Chelsea Physic Garden, transformed it into a model botanic collection.

The Society of Gardeners was an organization of nursery owners and gardeners who met monthly during the 1720s to discuss the improvement of gardening and to show and compare plants from their gardens. Philip Miller, whose celebrated *Gardener's Dictionary* (cat. 26) went through eight editions beginning in 1731, is generally believed to have authored this work. It is a "deluxe" catalogue of plants that were being grown and offered for sale by the members. Interestingly, ten of the trees were grown from seed sent from America by the naturalist Mark Catesby, who traveled in the Carolinas in the 1720s (and compiled and illustrated *The Natural History of Carolina, Florida and the Bahama Islands*, 1729–47).

The text lists the trees alphabetically by genus, giving the "generally received" Latin and common English names. One purpose of this book was to try to standardize the names of plants to be sold. Before a generally agreed-upon systematic naming of plants, which didn't come into use until the mid-eighteenth century publication of Linnaeus's *Species plantarum*, the same plants were being sold by different nurserymen under different names, leading to much confusion for gardeners and botanists. In addition to the names, a description of the botanical characteristics of the tree is noted, the various species are listed, and brief mention is made of "the Soil and Situation which is most agreeable to each Species" (Preface, 15).

Because the Society was producing this work without a patron, it was decided to issue it in parts to manage the expense of producing so many plates. As it turned out, only the first part on trees and shrubs was published, along with twenty-one plates, most of which were prepared for later sections. Seven of the twenty-one plates are interesting in the history of botanical art. They were among the first botanical plates to be color printed, using a technique in which the metal plate was roughened by a rocker, then color was dabbed on with a tool wrapped in rags (called "à la poupée," because the tool looked like a doll's head.) The mezzotint that resulted was then touched up with hand coloring. Except for a few instances, the method was not widely used in botanical printing (Dunthorne, 68).

CAT. 24

25. JOHN HILL (c. 1716–1775)

Eden, Or A Compleat Body of Gardening. London: T. Osborne, T. Trye, S. Crowder, and H. Woodgate, 1757.

John Hill studied botany during his apprenticeship as an apothecary, then worked as a bota-

CAT. 23

Batty Langley was an architect, gardener, and landscape designer. He expounds on his ideas for more natural landscapes in this book, criticizing the fashion of stiff lines of evergreens and formal arrangements of trees. He promotes planting for shade, retaining hills and valleys, and designing landscapes to look as if they were put in place by nature. His ideas were forward thinking; however, many of the fold-out engravings that illustrate his treatise seem to show his designs in the old style of parterres and rows of trees. The book exemplifies the period of change in the first half of the eighteenth century in English landscape design from artificiality to naturalism. Prominent colonial and Revolutionary War Americans owned this title, including George Washington, who purchased it in 1759 (Wulf, *Founding Gardeners*, 26) and it influenced the design of their estates.

New Principles of Gardening contains much practical instruction in the geometry of design, planting, and caring for fruit trees, shrubs and evergreens, and vegetables and herbs, as well as some flowers. In the plate shown here of a garden at Twickenham, where Langley lived, the earth taken out when the ponds were dug is used to raise the land at "A" to provide views over the Thames and countryside. "R" is a ha-ha, which is a narrow canal of water that acts as a fence from the road. Langley favored ha-ha's because, as opposed to gates, one could have views over them. Views were very important in his garden plans; he used sections of grass because one could see over them, and placed ruins at the end of walkways as focal points.

24. SOCIETY OF GARDENERS

Catalogus Plantarum, A catalogue of trees, shrubs, plants and flowers, both domestic and exotic, which are propagated for sale in the gardens near London. London: Printed for the Society of Gardeners, 1730.

by a previous owner relate the figures to those represented in Curtis's *Botanical Magazine*.

The title is a play on the author's name, *Paradisi in Sole*, meaning "a park in the sun." His love of plants is reflected in his writing and in the descriptions of the flowers growing in his own garden, of which this is essentially a catalogue. The book is also a window into horticulture of the seventeenth century, showing what was being grown and who were the botanists and gardeners of the period. It remained popular through the centuries and across the ocean, especially since it was written in English. In 1729, John Bartram in Philadelphia was given a copy of the book (Reveal, 49). However, it was often difficult to associate American plants with their English counterparts, especially since a systematic science of classification had not yet been developed (ibid., 16). In the late nineteenth century, Parkinson's book enjoyed a revival of interest, as it represented "a garden of delight" as opposed to the strict "carpet bedding" schemes of the Victorian Age. A Parkinson society was founded with the purpose being to grow old garden flowers and share seeds and garden books (Henrey, I:164).

CAT. 22 CAT. 22

23. BATTY LANGLEY (1696–1751)

New Principles of Gardening: Or, the laying out and planting parterres, groves, *wildernesses, labyrinths, avenues, parks, &c.* London: Printed for J. Batley, T. Bowles and J. Bowles, 1728.

Horticulture

HORTICULTURE, the cultivation of a garden, including flowers, fruits, vegetables, and other ornamental plants, became a craze in England in the mid-eighteenth century. In Europe in the Middle Ages, and in America in the early days of the settlers, gardens were maintained mostly for practical uses such as medicinal, or fruit or vegetable growing. On both continents, as more wealth developed, large landowners grew plants for pleasure, and eventually most houses had at least an arbor and a small garden. Americans returning from visiting England in the first half of the nineteenth century wanted to improve their gardens. Horticultural societies, botanic gardens, and botanical journals in England, Europe, and America promoted all the new plants discovered by explorers and gardening information was at a premium.

Horticulture books, as distinct from botany books, focused on either landscape design, practical gardening operations, names and origins of plants being grown, or commercial production of plants and seeds (Hunt, II:xxxii). The books shown in this section are all English and are among the earliest works in the collection, all but two being from the mid-seventeenth to mid-eighteenth centuries. In America at that time there were only two books that had any horticultural information and those were books on agriculture, reprinted in America from English sources (Hedrick, 467). The first original American horticulture book, Bernard M'Mahon's *American Gardener's Calendar*, was published in 1806, but for several decades during the nineteenth century, almost all of the books published in America were books on fruit growing or on the science of botany, both shown in this exhibition in separate sections. Americans at mid-century obtained most of their gardening information from the journals that had just begun to be published, also shown in another section of this exhibition.

22. JOHN PARKINSON (1567–1650)

Paradisi in Sole Paradisus Terrestris. London: R. N. for R. Thrale, 1656. Second edition.

Seventeenth-century England experienced an explosion of books on botany and horticulture. John Parkinson was an apothecary whose 1629 first edition of *Paradisi in sole paradisus terrestris* was "the earliest important treatise on horticulture to be published in this country" (Henrey, I:79). It is in the tradition of the herbal, essential to physicians, apothecaries, and housewives because it named and described plants with their medicinal properties. However, Parkinson's book also falls into the category of horticulture because he also treats the flower garden, kitchen garden, and orchard as pleasure gardens, therefore including in his work plants that have no medical use.

The full-page woodblock plates illustrate many species. It was common at this time to use blocks from others' earlier works, but most in this book are new and original. The annotations

CAT. 20

CAT. 21

21. FRANÇOIS ANDRÉ MICHAUX (1770–1855)

Histoire des Arbres Forestiers de l'Amérique Septentrionale, consideres *principalement sous les rapports de leur usage dans les arts et de leur introduction dans le commerce, ainsi que d'après les avantages qu'ils peuvent offrir aux gouvernemens en Europe et aux personnes que veulent former de grandes plantations.* Paris: L'Imprimerie de L. Haussmann, 1810–1813. 3 vols.

François André Michaux, a great nineteenth-century French naturalist and son of André Michaux, traveled in America with his father from 1785 until 1790, when he returned to France to study medicine and take part in the French Revolution. He returned to America in 1801 and up through 1809 traveled through the East and Midwest, collecting trees for the French government. This is the first volume (of three) of the original issue of this work, which was published in France in twenty-four parts between 1810 and 1813. The English translation, *The North American Sylva,* became the standard work on American trees for the remainder of the nineteenth century.

The beautiful plates were stipple-engraved, printed in color and hand-finished after drawings by the renowned artists and brothers Pierre Joseph and Henri-Joseph Redouté, and Pancrase Bessa. They show the leaves and cones, nuts, or berries of the trees with their Latin and English names, and describe in great detail where they were found growing, their size, features of their growth and their habitats.

Peter Kalm, a student of Linnaeus's, was sent to America by the Swedish Academy to hunt for plants that could be of use in Sweden. This work is a travel diary with natural history descriptions of northeastern America, where he traveled from 1748 to 1751. Kalm collected plants in Pennsylvania and New Jersey in 1748, traveled through New York to southern Canada the following year, and into western Pennsylvania and New York before returning to John Bartram's garden in Philadelphia. He returned to Sweden in 1751 with dried specimens and seeds for Linnaeus to name. *Travels into North America* was originally published in Swedish between 1753 and 1761.

Kalm's diary entries for Philadelphia are particularly interesting because he refers often to John Bartram, who shared his knowledge of American species with him. They demonstrate how interrelated the botanists were with each other. Kalm refers to a Larch tree which Miller's *Gardener's Dictionary* (cat. 26) says was seen in John Collinson's garden. Kalm finds out that John Bartram had sent that tree to Collinson and learns Bartram's thoughts on how apples were found in this country.

20. WILLIAM BARTRAM (1729–1823)

Travels through North and South Carolina, Georgia, East and West Florida, the Cherokee Country, the extensive territories of the Muscogulges or Creek confederacy, and the country of the Chactaws. Containing an account of the soil and natural productions of those regions; together with observations of the manners of the Indians. London: Reprinted for J. Johnson, 1794. Second edition.

William Bartram inherited his father, John Bartram's, botanical interests and famous garden, and "was one of the best observers in botany and ornithology that America has produced" (Hedrick, 91). He had traveled with his father on plant hunting trips and was well schooled in the observation of nature and in Linnaean classification, both of which talents are displayed in his *Travels*. He was also an accomplished illustrator, as can be seen in the plates.

First published in Philadelphia in 1791, *Travels* was composed during the late 1770s and early 1780s, based on diaries of Bartram's exploration of the Southeast from 1773–1778. The British plant collector and correspondent of John Bartram's, John Fothergill, was William Bartram's patron in this endeavor, expecting to receive seeds and plants that he could grow in his own garden. Fothergill had 3,000 exotic plants in his garden and a 260-foot greenhouse, and employed artists to draw the new plants introduced into his garden. He bought William Bartram's drawings and paid for Bartram's trip in the interest of science, but hoped that after exploring the South, Bartram would then travel to Canada, for Fothergill wanted to acquire live plants that could grow in the colder climate of England (Regis, 44).

Bartram produced a lyrical narrative of his travels, showing his awe at seeing the beauty of the scenery, along with a careful description of the land, animals, and plants. He was interested in the native Americans, through whose territory he traveled, and described them as an anthropologist would, recommending that scientists live among them and study them. *Travels*, his only major written work, entered "the canon of American Literature through the auspices of readers such as Wordsworth, Coleridge, Emerson, and Thoreau" (ibid., 43).

Jersey. He traveled extensively throughout the eastern United States, sent 60,000 plants to France (few of which survived) and, in 1796, when he returned to Paris, brought back forty boxes of seeds (Hedrick, 192). His son, François André, who traveled with him, later published his father's unfinished botanical work, *Flora boreali-americana* (1803), and his own work on the trees of America (cat.21). Thomas Jefferson had hoped that the elder Michaux would explore the West, but they were not able to raise the funds (Reveal, 68–70). It wasn't until after the Louisiana Purchase that Jefferson, as president, was able to arrange to send his personal secretary, Meriwether Lewis, and Lewis's friend, William Clark, on their famous journey to the Pacific.

Even earlier, the American botanists John Bartram (1699–1777), and later his son William (1739–1823), explored the eastern part of the United States as far as Florida, observing and collecting seeds and plants for the elder Bartram's own gardens and for his burgeoning business sending seeds and plants to Europeans, including Linnaeus. Linnaeus in turn sent his pupil, Peter Kalm, to America in 1748, where he met with Bartram and Benjamin Franklin during his stay in Philadelphia, and subsequently traveled through Pennsylvania, New Jersey, New York, and southern Canada, recording his observations. On his return to Sweden in 1751, he asked Linnaeus to name his findings, which may have stimulated Linnaeus to work on his *Species Plantarum* (1753), since he needed to account for all the new species that Kalm found (Reveal, 57).

Botanical exploration fueled the exchange of plants and knowledge between America and Europe as well as between Europe and far-flung continents of the East. It was responsible for the mixing of plants from all over the world in Western gardens, the study of these plants, their habitats, and cultural needs, and led to the sharing of knowledge at universities, botanic gardens, and horticultural societies. Many botanical explorers either drew their findings themselves or brought along artists to record their discoveries while the plants were still alive. After Linnaeus began to develop and publish his system of classification, starting with *Systema Naturae* in 1735, people had a common language with which to understand discoveries and compare examples of new plants with those of known plants. This made it possible for explorers to describe what they had found in a way that would be understood wherever their writings reached.

19. PETER KALM (1717–1779)

Travels into North America; Containing its natural history, and a circumstantial account of its plantations and agriculture in general, with the civil, ecclesiastical and commercial state of the country, the manners of the inhabitants, and several curious and important remarks on various subjects. Translated into English by John Reinhold Forster, F. A. S. Warrington: Printed by William Eyres, 1770. 3 vols.

18. D. M. [DELLON MARCUS] DEWEY (1819–1889)

The Nurserymen's Pocket Specimen Book, Colored from Nature, Fruits, Flowers, Ornamental Trees, Shrubs, Roses, &c. Rochester, NY: D. M. Dewey, Horticultural Bookseller, 1876.

CAT. 18

In the mid-nineteenth century, Rochester, New York, developed into a center of the nursery gardening business. Salesmen needed representations of their wares to take on the road with them, and a business of providing illustrations grew up in the area. At first, local artists would copy watercolors, but soon the use of stencils became more efficient. Flowers, or more often fruit, would be stenciled and then colored by hand, or later they would be chromolithographed, and still often touched up by hand.

Dellon Marcus Dewey was a local bookseller who collected these plates and published them, after which a selection representative of the salesman's wares would be bound together into conveniently sized (usually 6 x 9 inches) books, producing a personalized trade catalogue. Dewey was the major provider of these plates, which were labeled with his name, the variety of plant or fruit, some descriptive information, and the season of ripeness.

Exploration

WHEN EXPLORERS came to the New World searching for gold, spices, or conquest of land or souls, they also discovered unfamiliar plants and animals. They brought seeds, roots, and plants back with them to Europe, and although most of their discoveries were lost or damaged during the long voyages, some were able to be grown there, and word of their findings encouraged others to travel specifically for the plants.

This was particularly the case after the American Revolution, beginning with André Michaux (1746–1802), a well-known French botanist, who came to America in 1785 with a commission from Louis XVI and a letter of introduction to Washington from Lafayette, as well as a collection of trees and shrubs that he planted in his garden in New

fruit trees were imported to America from Europe, where the climate and cultural practices were different. The names of fruits were often not standardized so that growers here may be growing the same fruits but calling them by other names. This was particularly important when searching catalogues for fruit trees to buy since there were over a hundred varieties of just apples and pears.

Downing was determined to encourage Americans to plant fruit trees and give them the knowledge needed to know the many varieties available and to grow them well. For many varieties he showed an outline, similar to a facial profile, of the fruit. In this 1850 edition, the plates were stereotypes from the first edition (Raphael, 158). After each variety name there are abbreviated names of sources of information, usually English authors of important horticultural works. These are followed by a list of synonyms for the variety, and information on where the fruit originated and how to grow it in America. The book went through many editions and was the standard pomology reference work up to 1900.

17. C. M. [CHARLES MASON] HOVEY (1810–1887)

The Fruits of America. Vol. I, Boston: C. C. Little and Jas. Brown, and Hovey & Co., 1851 [bound with] Vol. II, Boston: Hovey and Co., 1856.

Charles Mason Hovey was a nurseryman, strawberry and camellia breeder, editor and author of an important horticultural journal, and an active participant in the Massachusetts Horticultural Society. With the profits from his strawberry seedling, he was able to purchase forty acres in Cambridge, Massachusetts for his business, Hovey's Nursery, which "contained more than 100,000 trees of over 2,000 different varieties, planted along radiating avenues" (Pauly, 60).

In the Preface to the first volume of *Fruits of America*, the contents of which were issued on a subscription basis on the first of every other month, Hovey speaks of the national pride he takes in producing this work, "that is, the delicious fruits that have been produced in our own country, many of them surpassed by none of foreign growth,-- and which are rendered doubly the more valuable, because inured to our climate and adapted to our soil,- will be here beautifully depicted." This copy has all of the parts that were issued between 1847–1856, including the incomplete third volume.

The plates were drawn and chromolithographed by William Sharp, who moved from England to Boston in 1841. Sharp was a pioneer in this process in America, and was particularly known for his work on these plates and for his magnificent plates for John Fisk Allen's *Victoria Regia: or the Great Water Lily of America* (Boston, 1854).

CAT. 17

25

15. ALFRED HOFFY, ed.

The Orchardist's Companion. Philadelphia, 1841.

The Orchardist's Companion was the first American journal devoted to growing fruits. It was dedicated to the Pennsylvania Horticultural Society (founded in 1827) which, in turn, recommended it to its members. Although intended to be issued quarterly, its publication soon ceased, most likely due to the production expense of the beautiful fruit portraits, all of which were drawn from nature by Hoffy and lithographed by him or his students, D. S. Quintin or Edward Quayle. The fruits were supplied by gardens in Philadelphia (Raphael, 157). Volume 1 consists of papers delivered at various horticultural meetings, descriptions of grafting, pruning and other practices, and articles and letters about fruit cultivation. Each fruit is listed with other names they were given in Europe and America. Frequent references to John Lindley and the Horticultural Society of London show how connected American horticulturalists were with their English counterparts.

CAT. 15 CAT. 16

16. A. J. [ANDREW JACKSON] DOWNING (1815–1852)

The Fruits and Fruit Trees of America. New York: John Wiley, 1850.

A. J. Downing was very influential in the history of horticulture in America, even though he died young. Most well known for his *A Treatise on the Theory and Practice of Landscape Gardening* from 1841, *Fruits and Fruit Trees of America* was as important to fruit culture as his earlier work was to landscape gardening. Downing was the owner of a nursery in the Hudson Valley and a major supplier and promoter of fruit trees, as well as other trees and ornamental plants. Most

Alfred Hoffy reflected on the value of fruits in the preface to *The Orchardist's Companion* (1841) (cat. 15): "To comment on the grateful and nourishing properties of the various fruits of our country, would be superfluous. . . . The finest, strongest and heartiest race of men are to be found, from amongst that class whose chief food consists in fruit" and this should act "as a spur to our most strenuous exertions in raising our orchards to the highest perfection and multiplying our fruit plantations."

In America, until the early nineteenth century, when books and magazines began to give instruction and horticultural societies were founded, there was no pruning, mulching, or insect and disease control. The American books discussed here were efforts to supply that information as well as to encourage large estate owners and farmers to plant and grow superior varieties of fruits that would survive and thrive in the climate and soil of America.

14. HENRI-LOUIS DUHAMEL DU MONCEAU (1700–1782)

Traité des Arbres Fruitiers. Paris: Chez Saillant & Chez Desaint, 1768. 2 vols.

Henri-Louis Duhamel du Monceau, French botanist and gardener, produced this example of a French fruit book in 1768, having already published a book on trees. He begins the first volume discussing pruning and grafting, techniques that were important if choice varieties were desired. He treats almonds, apricots, cherries, apples, peaches, plums and more. For each fruit he gives a long general description followed by detailed descriptions of each variety, the culture, and then methods that different growers use to produce the best fruit, as well as uses for the fruit. In his descriptions he made an effort to distinguish common varieties from botanical species. Full-page uncolored (in this edition) engravings of each of the varieties follow.

The plate shown illustrates grafting techniques, which are fully described in the preceding chapter.

CAT. 14

Fruit Books

"The nurture of trees bearing edible fruit has been going on almost as long as gardening itself."
(Raphael, xxiii)

Books about fruit growing had been published as early as the sixteenth century in Italy, and fruit trees were imported into England from France and Holland in the seventeenth century. One well-known French fruit book from the eighteenth century as well as several nineteenth-century American books are shown in this section.

When the Pilgrim settlers arrived in the New World, they brought with them tools, crops, seeds, and gardening knowledge from England and Holland. They learned to grow native crops from the Indians, and discovered native fruits in the woods. The woods had wild raspberries, blackberries, cranberries, strawberries, and grapes, but none were cultivated in gardens and the varieties, of course, had no names. The climate was harsher than that in their homeland, but the soil was more fertile. Apple trees, indigenous to America, were hardy, but fruit trees from home needed to adapt to the changed environment and often froze or became diseased.

The most important fruit grown in America was the apple, since cider was the standard drink. When the fruit was used for cider or brandy, it didn't matter if it was damaged by insects or diseases or was an unnamed variety. The early eighteenth century was likely the beginning of the practice of grafting better varieties onto stronger rootstocks. These varieties were carried through the colonies by itinerant grafters. In 1759, Benjamin Franklin sent Green Newtown apples to London, where they became so popular that people wanted grafts, and his fellow Philadelphian, John Bartram, developed a big exporting business beginning with apple grafts.

The colonies of Pennsylvania, Delaware, and New Jersey enjoyed a milder climate, more fertile soil, and more friendly Indians than New England, so fruit growing and agriculture in general became very important. The Pennsylvania Dutch were famous for their orchard products. Peaches and grapes were native, and grafting and pruning were practiced. Before central and western New York were settled by foreigners, Indians grew peaches and in the mid-eighteenth century, they were also growing plums, apples, and grapes. Long Island's soil was very similar to Holland's so the Dutch taught others that immigrated there how to garden. A nursery was founded in Flushing, New York, in 1737 by Robert Prince, and in 1771 he published the first catalogue of fruits in America (Hedrick, plate IV).

Early horticulturalists focused on fruit growing. Many of the articles and plates in the *Transactions of the Horticultural Society of London* (cat. 31) were about fruit, as were the articles in American botanical journals. In flowery nineteenth-century style,

Elements of Botany, written when the author was just twenty-six, was his attempt to write "an original work, expressly adapted to students of North American botany" (Gray, x) instead of adapting one of the European masterpieces, which had expensive engravings and were too complicated and large for the stated purpose. This became the standard work and, through many editions, remained so for fifty years.

13. CHARLES F. MILLSPAUGH, M.D. (1854–1923)

American Medicinal Plants. New York and Philadelphia: Boericke and Tafel, 1882–87.

This late nineteenth-century medical botany was originally issued in parts, then gathered into two volumes in book form, with chromolithographed plates. The author writes in his Prospectus that he drew and colored the plants himself from live specimens "as they stood in the soil" so that there would be no misrepresentations or problems relating to wilted plants, and the "country practitioner" could easily recognize them.

He included plants "only such as may be found in that district of North America in which most of the Homoeopathic physicians reside." In addition to the careful botanical description of each plant necessary to identify it, he also gave the history and habitat, the parts of the plant that were used for the tinctures and the method and ratios used in the preparations, the chemical constituents if they had been studied, and the physiological action that resulted.

AILÁNTHUS GLANDULÓSUS, Desf.

CAT. 13

the ORDER is *Monogynia*, in which *monos* is one and *gune* is pistil. Therefore Narcissus is in the Linnaean Class and Order of flowers which have six stamens and one pistil. The author deliberately eliminated all the other Latin and Greek terms common in books on botany. The introduction to the book has a complete and clearly-written explanation of Linnaeus's classification system.

Each entry has a hand-colored engraving of the flower, a list of the different species, a poem concerning the generally accepted symbolic meaning, and a somewhat folksy description of the plant. As this is a book on botany, not gardening, there is no information on how, when, or where the plants grow.

CAT. 12

12. ASA GRAY, M.D. (1810–1888)

Elements of Botany. New York: G. & C. Carvill & Co., 1836.

Asa Gray was the preeminent American botanist of the nineteenth century. As Professor of Botany at Harvard he trained most of the late nineteenth-century botanists who went on to develop the science, and was a close associate of important naturalists and botanical explorers. Gray, along with his mentor, John Torrey, helped in organizing the plants brought back from Western exploration, and in establishing botany as a science separate from medicine. He was also an early believer in and proponent of Darwin's theory of natural selection. His name can be found in almost every reference work on botany in America.

10. SIR JAMES EDWARD SMITH (1759–1828)

A Grammar of Botany, Illustrative of artificial, as well as natural classification *with an explanation of Jussieu's System. To which is added a reduction of all the genera contained in the catalogue of North American plants, to the natural families of the French professor, by the late Henry Muhlenberg, D.D.* New York: James V. Seaman, 1822.

This American edition of a British work is notable for two reasons: it gives a full explanation of Jussieu's Natural System and compares it to Linnaeus's Artificial System in a manner that a student could understand and the plates bound in the back of the book are early American examples of hand-colored lithographic illustrations. The Introduction to this edition proudly states that the drawings "are specimens of American Lithography," drawn by Arthur J. Stansbury (1781–1845), a writer and illustrator of children's books (Bennett, 99) and "executed at the Lithographic Press of Barnet & Doolittle of this city" (Smith, vi). Lithography was just getting started in America at the time of the publication of this book. Previously, books were largely illustrated by hand-colored copper engraving, an expensive process which accounts for why many American botanical books were not illustrated, making proper identification of plants that much more difficult.

CAT. 10

The numbers next to the specimens in the plates refer to a table that lists the simple description.

11. H. BOURNE

Flores Poetici. The Florist's Manual: Designed *as an introduction to vegetable physiology and systematic botany, for cultivators of flowers. With more than eighty beautifully-coloured engravings of poetic flowers.* Boston: Munroe and Francis; New York: Charles S. Francis, 1833.

This book presents botany for the beginner. The flowers are common ones which would have been well known to Americans and their descriptions explain the Latin botanical terms. For the Narcissus shown here, for example, the CLASS is *Hexandria,* explained as coming from the Latin *hex* meaning six and *aner* meaning stamens, and

CAT. 11

Curtis employed a stable of the finest artists and engravers for this project, including James Sowerby, William Kilburn, and Sydenham Edwards, all of whom went on to work on the *Botanical Magazine* (cat. 29) and other important eighteenth- and nineteenth-century botanical works. He also employed about thirty artists to hand-color the illustrations, among them William Graves, the father of the man who eventually published the second edition. Roadside weeds received the finest artistic treatment in these volumes, which leave a very complete record of the plants growing naturally in England in this period. As such it is an important document in botanical history.

9. WILLIAM P. C. BARTON (1786–1856)

A Flora of North America. Illustrated by coloured figures drawn from nature. Philadelphia: M. Carey & Sons, 1821 (Vol. I), H. C. Carey & I. Lea, 1822–1823 (Vols. II & III).

William Paul Crillon Barton was the nephew and a student of Benjamin Smith Barton, whom he succeeded as professor of botany at the University of Pennsylvania. He served as a surgeon in the Navy and was the first chief of the Navy's Bureau of Medicine and Surgery. In America in the early nineteenth century, all botany was related to medicine. Before publishing *A Flora of North America*, Barton had published *Vegetable Materia Medica of the United States* (1816–1818) a book very similar to *Bigelow's American Medical Botany* (1817–1821) (cat. 7). Bigelow had also been a student of Benjamin Smith Barton's but had moved to Massachusetts to practice medicine and teach at Harvard. Apparently, each did not know that the other was preparing a similar work, and when they found out, continued to publish their own.

The plates are all based on Barton's drawings from nature and the book was produced entirely in America. There is some discussion about whether the plates were actually printed in the way Barton describes. In the preface to Volume I, Barton calls attention to the process that "consists of that kind of graphic execution in which so high a degree of perfection has been attained in France, in the plates of Michaux's splendid work on the Forest Trees of America" (cat. 21). In that work, Redouté's process of applying colors "à la poupée" to a plate and printing in color was employed. Redouté was known for the stipple engraving process, which leaves tiny dots and a softer impression. *A Flora of North America* was the first American book to successfully use stipple engraving for some of the plates. This copy is engraved in black and white and hand-colored, as is obvious in the plate shown, with some use of stipple engraving as well.

CAT. 9

8. WILLIAM CURTIS (1746–1799)

Flora Londinensis: Containing a history of the plants indigenous to Great Britain, *Illustrated by figures of the natural size. A new edition enlarged by George Graves.* London: Printed for George Graves, Vol. 1, 1817; Vol. II, 1821; Vol. III, 1826; Vol. IV, 1821.

CAT. 8 CAT. 8

William Curtis was an apothecary who left his profession to follow his hobby of botany. He worked at the Chelsea Physic Garden and then created his own garden, sustained by subscription memberships, in which he grew 6,000 species of plants (Keeler, 67).

The original edition of this book, published in two volumes, the first dated 1777 but actually published in 1781 (Henrey, II:666), and the second in 1798, was a massive undertaking and favorite project of William Curtis. Derived from his botanizing trips into the countryside, it was his effort to record all the plants growing wild within ten miles of London, along with their botanical information. Although he had the patronage of the Earl of Bute and others, the project was not popular with the public, who were interested in exotic plants, not the weeds that grew around them, and so was a financial failure and left unfinished. He went on to found the very successful *Botanical Magazine* and published other catalogues and books.

When Curtis died, the plates and text passed to his son and then to George Graves, who published a greatly enlarged edition in five volumes, adding 200 plates and a revised text by William Jackson Hooker. The copy in this exhibition is a second issue of the Graves edition, in four volumes, with the plates and botanical descriptions reorganized according to Linnaeus's system and indexes added. The book is folio sized which allows for life-size depiction of the plants.

7. JACOB BIGELOW, M.D. (1787–1879)

American Medical Botany, Being a collection of the native medicinal plants of the United States, Containing their botanical history and chemical analysis, and properties and uses in medicine, diet and the arts, with coloured engravings. Boston: Published by Cummings and Hilliard, 1817–1820. 3 vols.

CAT. 7

Jacob Bigelow was introduced to botany by Philadelphia botanist and professor, Benjamin Smith Barton, while in medical school at the University of Pennsylvania. He returned to Boston to open his practice, became a professor at Harvard Medical School and was the major force behind the founding of Mt. Auburn Cemetery by the Massachusetts Horticultural Society.

Bigelow's purpose in producing this work was "to offer to the public a series of coloured engravings of those native plants, which possess properties deserving the attention of medical practitioners." Each plant was carefully drawn by him with its important parts dissected so that readers could use it as a guide. The text, which is straightforward and practical, explains where the plant grows, describes it botanically, discusses the taste, smell, and other properties of its parts, gives research findings by other practitioners, experiments that they may have conducted, and various uses in treating illnesses or their dangers of use (as in the hemlock shown here.) At the end of each article, botanical and medical references are cited.

This is one of the earliest color plate books published in America (Bennett, 11), and an unusual one. It was intended that the first ten plates would be engraved and hand-colored and the following fifty plates would use a process of color printing unique to this book. In this copy, all but possibly the first plate in Volume I were color-printed. In the "Advertisement" in Volume II (of three volumes), Bigelow states proudly that "the style of engraving is wholly new to this country, and is one which has been successfully attempted only by the first artists in France" (Bigelow, vi). There is an unresolved debate about whether the plates were etched stone with colors applied with a cloth "à la poupée" (Reese, 40), or whether the plates were etched on metal and printed in color by aquatint. In either case, the plates were color printed and some were then hand-colored as well.

CAT. 5

CAT. 6

6. FREDERICK PURSH (1774–1820)

Flora Americae Septentrionalis; Or, a systematic arrangement and description of the plants of North America. Containing, besides what have been described by preceding authors, many new and rare species, collected during twelve years of travels and residence in that country. London: Printed for White, Cochrane, and Co., 1814.

Excited by plants brought to Europe from North America, Pursh set off from Dresden in 1799 to explore America, collect native plants, and to form an acquaintance with all those interested in Botany (Preface, vi). He details his travels from Baltimore to Philadelphia and the southern and northern states, traveling on foot through mountains and forests. He met and worked with a pantheon of early American botanists, among them William Bartram (cat. 20) and his father, John Bartram, Humphry Marshall (cat. 3), and Benjamin Smith Barton.

His acquaintance with the explorer, Meriwether Lewis, led to being entrusted with herbaria samples from the Lewis and Clark explorations in the West for the purpose of having Pursh study and draw them so that Lewis could include them in his own book on his travels. Lewis died before publication, so Pursh's inclusion of them in this work is the first published record of Lewis and Clark's botanical findings. There is a question about whether these plants were really Pursh's to do with as he pleased. Regardless, in his book he listed 130 of Lewis's plants, many of them new species and genera never before recorded, which he designated as "M. Lewis," or "in Herb. Lewis."

4. SAMUEL STEARNS (1747–1819)

The American Herbal, or Materia Medica. Wherein the virtues of the mineral, vegetable, and animal productions of North and South America are laid open, so far as they are known; and their uses in the practice of physic and surgery exhibited. Walpole: Printed by David Carlisle, for Thomas & Thomas, and the Author, 1801.

Samuel Stearns was born in Massachusetts, and during the Revolutionary War he was jailed for his Tory sympathies (Johnston, 627). He moved to Vermont and Quebec, traveled in France and England, and received a law degree before returning home to practice in New England.

In his PREFACE TO PHYSICIANS, SURGEONS AND APOTHECARIES, he explains that he "was instructed in the medical art, according to the methods that were in vogue in the younger part of his life" but he finds fault with this instruction, because there were no established rules for teaching or compounding remedies. For the "MASTERS and MISTRESSES of FAMILIES" he says that they should be able to understand this work and be able "to be their own physician in some measure" by knowing the possible dangers in nature. The subscribers to the book were northern New Englanders and Canadians.

This is the first herbal compiled and published in America. As practical guides, these books endured heavy use. The plants are listed by their common name, with the botanical name in use at the time given below. Few identifying characteristics of the plants were given, so readers must have been expected to be familiar with them.

5. WILLIAM JOWIT TITFORD, M.D. (1784–c. 1823)

Sketches Towards a Hortus Botanicus Americanus; Or, coloured plates (with a catalogue and concise and familiar descriptions of many species) of new and valuable plants of the West Indies and North and South America, also of several others, natives of Africa and the East Indies: arranged after the Linnaean system. With a concise and comprehensive Glossary of Terms, prefixed, and a General Index. London: Printed for the Author by C. Stower, 1811.

This book, by a physician who lived on the island of Jamaica and traveled extensively in the United States, is one of the earliest to depict plants of America. Titford executed all the drawings for the hand-colored plates. It was originally published in parts, which likely explains how the title page and all but one of the first nine plates are dated 1811 while plates X–XVII are dated 1812. The plate shown here is not dated.

As stated in the comprehensive subtitle, the plants are arranged by classes and orders of the Linnaean system and a further description of each of the plants pictured follows the glossary of terms. The list of subscribers in the back shows New Yorkers, among them DeWitt Clinton as well as Dr. David Hosack, founder of the Elgin Botanic Garden, Philadelphia botanists, and residents of Jamaica, Bermuda, London and other cities in England and America. No other works by this author are known.

etc. of their several species and varieties. Also, some hints of their uses in medicine, dyes, and domestic œconomy. Philadelphia: Printed by Joseph Crukshank, 1785.

This is the first book published in America devoted to American botany (Ewan, 4). Humphry Marshall was a relative of John Bartram. Both were from Chester County, Pennsylvania, both developed botanic gardens in which to grow and study the plants from their explorations and their exchanges with European collectors, and both were members of the American Philosophical Society, the Philadelphia group founded by Benjamin Franklin in 1769 for the purpose of "systematic correspondence between its members" and helping the sciences, especially botany and agriculture (Hedrick, 82). Both Marshall and Bartram contributed to making Philadelphia the center of botanical and horticultural information.

The book is dedicated to Franklin and other members of the American Philosophical Society. It covers only trees and shrubs, although the author states that he hoped to cover herbaceous plants when circumstances allowed. His descriptions of American trees, many of which were previously unknown to botanists and gardeners in Europe, made this a popular book there, and a 1788 edition was published in France. He also included before the index an advertisement for boxes of seeds and plants "made up in the best manner and at a reasonable rate by the Author." It is essentially a catalogue of the items he could supply, but with a twelve-page preface explaining Linnaeus's system and botanical nomenclature.

(62)

a corymbus, at the tops of the ſtalks, they are of a white colour, and are ſucceeded by ſmall capſules.

HYPERICUM.

St. JOHN's WORT.

Claſs 18. Order 3. Polyadelphia Polyandria.

THE *Empalement* is five parted: the diviſions are ſomewhat ovate, convex, and permanent.
The *Corolla* has five petals, oblong-ovate, obtuſe, ſpreading, and marked according to the motion of the ſun.
The *Filaments* are numerous, capillary, joined at the baſe into five or three parts or bodies. The *Antheræ* are ſmall.
The *Germen* is roundiſh. The *Styles* are three (ſometimes one, two, and five) ſimple, diſtant, and the length of the ſtamina. The *Stigmas* are ſimple.
The *Seed-veſſel* is a roundiſh capſule; with cells according to the number of the Styles.
The *Seeds* are many and oblong.

The Species *growing ſhrubby, with us,*

HYPERICUM kalmianum. *Virginian Shrubby Hypericum.*

This grows naturally in low wet places, riſing with ſhrubby ſtalks to the height of three or four feet, with oppoſite angular branches. The leaves are ſmooth and ſhaped like thoſe of Roſemary or Lavender. The flowers terminate the branches in ſmall divided cluſters of three or ſeven flowers; they have each five very ſlender ſtyles, and are ſucceeded by oval, pointed capſules, filled with ſmall ſeeds.

ILEX.

(63)

I L E X.

The HOLLY-TREE.

Claſs 4. Order 3. Tetrandria Tetragynia.

THE *Empalement* is four toothed, very ſmall and permanent.
The *Corolla* conſiſts of one petal, four-parted and plane: the diviſions are roundiſh, concave, ſpreading, pretty large, and cohering by claws.
The *Filaments* are four, awl-ſhaped, and ſhorter than the corolla. The *Antheræ* are ſmall.
The *Germen* is roundiſh. The *Style* none. The *Stigmas* are four and obtuſe.
The *Seed-veſſel* is a berry, roundiſh and four cell'd.
The *Seeds* are ſolitary, bony, oblong, obtuſe, gibbous on one ſide and angled on the other.
Obſ. The flowers are in ſome ſpecies male upon one plant, and female and hermaphrodite upon a different plant.

The Species *with us, are,*

1. ILEX Aquifolium. *American Common Holly.*

This grows in Maryland, New Jerſey, &c. generally in moiſt ground, riſing to the height of fifteen or twenty feet, with an erect ſtem, covered with a greyiſh coloured ſmooth bark, and furniſhed with pretty many branches, which are garniſhed with thick, hard, ever-green leaves, waved on their edges and indented, each point terminating in a ſtiff prickly ſpine. The flowers are produced upon pretty long footſtalks, often three parted from the ſides of the branches, of a white colour, having often five or ſix ſtamina, and the corolla divided into as many parts, and are ſucceeded by roundiſh berries, which when full ripe are red. Of the bark of common Holly is made Birdlime, which is better than that made of Miſletoe.

2. ILEX

bottom, holding a leaf of the potato plant. A year before the first edition of his *Herball*, Gerard published a catalogue of 1,000 species of plants in which the potato made its first appearance in print (Henrey, I:39). Even at this early date, plants found in America were being brought to England. Although Gerard grew it in his garden, "the potato was a rarity and a costly dish for the table until long after the age of Elizabeth I" (ibid., 69).

2. JOHN MILLER (1715–1790)

Illustratio Systematis Sexualist Linnaei per Johannem Miller, An Illustration of the Sexual System of Linnaeus by John Miller. London: By the author, 1770–1777. 3 vols.

CAT. 2

John Miller was born Johann Sebastian Mueller, changing his name when he moved to London from Nuremberg. He was an accomplished botanical artist as well as engraver, and besides the 104 engraved plates, in both uncolored and colored states in this work, he drew and engraved fourteen plates for the 1759 edition of Philip Miller's *Gardener's Dictionary* (cat. 26), as well as for other works.

The elegant large folio plates include all the parts of the plant, numbered to correspond with the Linnaean classification and description, in both Latin and English, on the facing page. Linnaeus himself highly approved of the work (Blunt, 150). The drawings were made by Miller from plants grown at the garden in Upton by John Fothergill, a naturalist and patron of this and many other works of natural history, medicine, and literature (Henrey, II:278). This work was issued in parts by subscription, as was common at the time, and the list of eighty-five subscribers includes Joseph Banks, John Fothergill, the British Museum, many persons of nobility, a few university libraries, several clergymen and booksellers, two of whom ordered ten sets each.

3. HUMPHRY MARSHALL (1722–1801)

Arbustrum Americanum: The American Grove, or, an alphabetical catalogue of forest trees and shrubs, natives of the American United States, arranged according to the Linnaean System. Containing, the particular distinguishing characters of each Genus, with plain, simple and familiar descriptions of the manner of growth, appearance,

1. JOHN GERARD (1545–1612)

The Herball or Generall Historie of Plantes. Enlarged and Amended by Thomas Johnson. London: Adam Islip, Joice Norton, and Richard Whitaker, 1636.

John Gerard, whose name in reference books leaves off the final *e* that appears on the title page, was trained as a surgeon and became a keen botanist and gardener for Lord Burghley, to whom he dedicated this work. Gerard did not claim to be a scholar. His herbal, as was the case with most in the sixteenth and seventeenth centuries, used as sources previously published herbals, to which Gerard added the English localities of plants and his experiences growing them. Of the 1,800 woodcuts, most were from woodblocks of a German publication of 1590. No matter how unoriginal or erroneous, it became a much consulted and valued book into the second half of the eighteenth century, and this revision by Johnson was a standard reference for colonial American plant collectors.

The first edition of Gerard's *Herball*, was published in 1597. This second amended edition by Thomas Johnson (the first being 1633) adds much material and corrects Gerard's admitted inaccuracies of the first edition. Thomas Johnson (c. 1597–1644) was a London apothecary, botanist, a writer who described his "herborizing" trips, and a more careful scholar who also had the advantage of almost forty years of expansion in botanical knowledge since the original was published.

The elaborate title page of this work has engravings of Ceres and Pomona, goddesses of wheat and fruit, along with Theophrastus and Dioscorides, early herbalists. Gerard's likeness is at the

because critics claimed that Linnaean classification resulted in unrelated plants being grouped together, arranged only according to the number of pistils and stamens and not natural characteristics (Saunders, 97). Most of the authors of botanical books in this exhibition refer to the Natural System as well as the Linnaean System in their works, and generally use Linnaeus's nomenclature. Botany was becoming more scientific and began to be taught as a discipline separate from medicine. Many other botanists developed systems of their own throughout the nineteenth century; today the classification of plants relies on DNA evidence.

Medical botany remained important in America as a legitimate scientific field longer than in Europe and England. In the early days in America, it was difficult for the settlers to know which plants in their new country were the same as plants that they may have used to make medicines in their homelands. Herbal books, which had been the main source of information in Europe, were not of much use in the new environment, except for a few plants that were listed as coming from the New World. Botanical literature devoted to *materia medica,* substances used in medicine, was not published in America until the early nineteenth century. Of the three American medical botany books shown in this exhibit, two of them are early for America (1801 and 1817) (cat. 4 and cat. 7), and the other is a later (1882) *materia medica* (cat. 13).

The science of botany in America began with John Bartram (1699–1777), a Philadelphia Quaker and the first American-born botanist, who was enormously influential. In 1746, after being introduced to European botanists by Benjamin Franklin, Bartram came into possession of Linnaeus's *Systema Naturae,* the earliest book in which Linnaeus began to develop his classification system. Bartram had already established a botanic garden in 1728, where he grew native and foreign plants, the latter of which he received from his correspondence with European plant collectors, most notably, fellow Quaker and Englishman Peter Collinson. Their voluminous correspondence from 1734 until 1768 enriched the fields of botany and horticulture both in America and Europe (Hedrick, 86). Collinson imported seeds and plants that Bartram gathered for him on his botanizing trips in America, and sent to Bartram boxes of rarities from Europe, which he then grew at his garden near Philadelphia. Both distributed these to their circle of friends so that American and European plants were introduced to collectors and botanists on both sides of the Atlantic.

The botany books shown in this catalogue date from 1636 to 1882. They were published either in London or in America and are arranged by date of publication, as are the books in each of the other categories. All but two of the botany books, Humphry Marshall's *American Grove* (cat. 3) and Samuel Stearns's *American Herbal* (cat. 4) contain illustrations. It was common for early books in America to lack illustrations.

Botany

FROM CLASSICAL ANTIQUITY until the seventeenth century, botany was virtually synonymous with medicine. Plants were studied for their uses in making remedies. The first botanic gardens, both in Europe and later in America, were known as physic gardens, where apothecaries and medical students learned the medicinal qualities of plants.

Herbals, the first botanical books, described plants and gave their medicinal properties. They were necessary information sources for apothecaries and physicians, and were also used by housewives to look up home remedies and treatment for such things as sleeplessness and melancholy (Henrey, I:5). For almost a thousand years, many herbals were translations of *Materia Medica* by Dioscordes, the first-century Greek physician and pharmacologist, in which he named and described 600 plants. The earliest herbals were continually copied in later centuries. Once European herbals began to be illustrated by woodcuts, the illustrations were also copied in later herbals. Gerard's *Herball* of 1636 (cat. 1) contains 1800 woodcuts, only sixteen of which are original.

During the eighteenth century, called the "Age of Reason" because of the explosion of information in all disciplines, the science of botany began to diverge from medical botany. Due to exploration, an influx of plants brought back to England and the Continent from foreign lands needed to be named, described, and illustrated. Previously plants were grouped according to superficial characteristics and by medicinal uses. Since these new plant specimens had not been seen before, their use was not known. It was apparent that an overall system of classification was necessary.

European botanists in the eighteenth century differed in the ways they classified plants. Carl Linnaeus, the Swedish naturalist, tried to standardize classification by basing it on the sexual parts of flowering plants. Twenty-four classes were based on the number of stamens, and each class was divided into orders, based on the number of styles or stigmas. Orders were then divided into genera and then into species. Plants were given two names based on the genus and species; thus his system of naming was called binomial nomenclature. He also gave plants descriptive phrase-names which became popular as well. Because of the ease of use of Linnaeus's system there was a tremendous increase in the number of botanical books published from 1760 until 1810 in England (Henrey, II:651). Linnaeus's classification emphasized the parts of the flower. As a result, illustration became more important in botanical works, and artists began to show the parts of the plant, often in dissection. In the two English books shown in this section, by John Miller (cat. 2) and William Curtis (cat. 8), the illustrations were executed by the finest artists of the day.

The so-called Natural System of Jussieu (Antoine Jussieu proposed this in 1789) arose

As I delved into collecting, I became more interested in the history of horticulture, especially in America, and began collecting books that were significant in that history but may not have the beauty of the colored plates. I now have examples of early herbals, diaries of botanical exploring, and expositions on botany, about which I wasn't knowledgeable earlier in my collecting and which now are so absorbing.

The collection is still mainly American, English, and Continental nineteenth-century color-plate books of botanical or horticultural interest, but I've added notable earlier works from the seventeenth and eighteenth centuries, as well as some from the twentieth century. There is a growing collection of children's books on gardening as well. The full range of illustration techniques can be seen in this collection, from seventeenth-century woodcut engravings to color lithography and photography.

This exhibition shows a selection of works to illustrate the range of botanical books printed from the seventeenth through nineteenth centuries. An effort is made to show the inter-relationships between American books and their English and Continental predecessors and contemporaries. The books are divided into categories: Botany, Fruit Books, Exploration, Horticulture, Botanical Journals, Florilegia, Children's Gardening Books, and Sentimental Works. Some of these works fall into more than one category, e.g., botanical journals include articles on fruit growing (Fruit Books), the science of plants (Botany), and plant hunting (Exploration); Children's Gardening Books are mostly sentimental, and Florilegia also refer to where the exotic flowers were discovered and may have botanical names and descriptions. I hope this exhibit communicates the pleasure and knowledge I have derived from my relatively short but intense love affair with botanical books and that it stimulates interest in the history of gardening through these works.

I would like to thank Marge Thomas, a good friend who was the first book collector I knew, and introduced me to my first dealers; Nicholas Goodyer, Eugene Vigil, Donald Heald and Jeremy Markowitz, from whom I purchased many of the books in the collection and who have guided me in my collecting; and my husband, Hersh Cohen, without whom I would not be a collector.

Foreword

———◆·◆·◆———

FROM MY BACKGROUND and interests, it would have been natural to assume I had become a collector of botanical books much earlier. As a child I was always interested in gardening, planting sunflowers in the three-foot patch of soil in our cement backyard, and growing a vegetable garden behind later houses as a teenager and then a wife and mother. I grow dozens of varieties of ornamental plants from seed each spring and volunteer as a Master Gardener with Cornell Cooperative Extension. I also always loved books. I would read stacks of library books every week during my elementary and high school years. And after many years as a classroom teacher, I switched careers to become a school librarian, spending my days reading books to children, guiding them in their selections of books, and choosing books for the library. Combining gardening and books seemed like a perfect pairing.

However, I did not think I had the "collecting instinct," my only collection being the stamps I pursued as a child. My husband, Hersh Cohen, is a passionate collector. The selection of prints in this exhibition is but part of his collecting. He also collects American paintings, Federal furniture, art pottery, weather vanes, and cast iron doorstops. I would watch him absorbed in the hunt, eagerly contacting dealers, doing research, admiring the collections, and I would enjoy the objects with him, but never feel the same urge to acquire something. That was until I discovered color-plate botanical books.

After 9/11, the annual Winter Antiques Show could not take place in the Armory but was instead held at a hotel, a much less intimidating space. It was at Bauman Rare Books' more modest than usual booth that I saw a book about greenhouse flowers opened to a hand-colored engraving. Suddenly, I wanted to own that book! I was building a greenhouse and, as noted, I have always been a gardener and a reader. It had an immediate impact.

That first purchase led to my pursuit of color-plate botanical books, and I quickly went through all the phases of collecting that my husband had before me. He taught me to avoid his early shortcoming in collecting – not being willing to stretch for the best – so the collection includes some of the most beautiful and significant of botanical books. Since his collections are all American, and since American botanicals have a shorter history and fewer collectors specialize in them, he has encouraged me to have a subspecialty in American botanicals. I owe my collection to his support and excitement for me.

7

CONTENTS

Catalogue of an exhibition held at
The Grolier Club
September 8 through November 4, 2011

ISBN: 978-1-60583-036-0

FERN COHEN

STEEL & ROSES

———————•❖•———————

American Prints in
the Hersh Cohen Collection & Botanical Books
in the Fern Cohen Collection

Part 2
BOTANICAL BOOKS

THE GROLIER CLUB

NEW YORK

2011